How to Operate a Successful Photo Portrait Studio

By
John Giolas, CR. Photog. CCP.

AMHERST MEDIA, INC. ■ BUFFALO, NEW YORK

About the Author

Known as the "Singing Photographer," John Giolas, Cr. Photog. CCP., has entertained and enlightened audiences by putting on programs, seminars and workshops all over the United States. Now in his 40th year in the business, John has written a book in hopes he may reach even more people who are interested in the business of Studio Portrait Photography.

One of Giolas' best known clients in the entertainment field includes The Jackson Five, during their early years. Many of the pictures which appear in their biographical book were taken by John Giolas. Some of his portraits are also displayed in the Jackson Five Museum. Among other celebrities photographed by John are Paul Stookey and Bob Hope.

Specializing in high school senior photography, John has photographed over 40,000 seniors in northwest Indiana during his 40 years in business.

Published by:
Amherst Media, Inc.
P.O. Box 586
Amherst, NY 14226
Fax: (716) 874-4508

Publisher: Craig Alesse
Senior Editor/Project Manager: Richard Lynch
Associate Editor: Frances J. Hagen
Photos by: John Giolas Photographers, Inc.

ISBN: 0-936262-69-9
Library of Congress Card Catalog Number: 98-72870

Printed in the United States of America
10 9 8 7 6 5 4 3 2 1

Table of Contents

Introduction

"...covers all the basic elements that make up a successful portrait studio."

When I started writing this book, I had no idea of what I could possibly say about my subject that hasn't been said before. Knowing that, I decided to put into words exactly what I did in my business. This book covers all the basic elements that make up a successful portrait studio.

Beginning with the equipment you'll need to start a portrait studio, the book takes you through the life of a studio. It covers how to get started, the types of photography you can offer, and how to get people to come to your studio. Every aspect of the portrait studio will be discussed, including: weddings, family portraiture, photographing children, proms, as well as lighting and posing essentials.

Although I consider myself a general practitioner, our speciality is high school senior portraits, or what I simply call "seniors." There will be heavy emphasis on seniors including how to get them to your studio, what to do when you get them in, and how to decide between being a non-contract or contract photographer.

My main reason for writing this book is to help people who are just starting out, or people who have been in the business for only a short time. In addition, it's for anyone who has been in photography for awhile and wants to take a refresher course.

Finally, I wish to thank all those folks whose brains I picked, whose work I tried to emulate, whose programs I attended, and the people who were kind enough to attend some of mine. It is my hope that I can pass my knowledge on to those who will follow. A special thank you goes to Dr. William R. Neil, Professor Emeritus, Indiana University, NW, for his assistance on the editing of this book, and to Mr. John Bir, CCP., who graciously contributed most of the photography in this book.

CHAPTER ONE

Equipment Needed to Get Started

"...equipment you need to get started..."

As we begin, I am going to assume that you already own a 35mm camera and are familiar with at least some 35mm flash photography. If so, we will discuss what other equipment you need to get started photographing people with professional results. Let's list the basic items you should consider buying at this time:

1. Camera

2. Lenses

3. Accessories

4. Electronic Flash

5. Studio Lights

Buying a Camera

A good medium format camera is a necessity. The medium format camera differs from your basic 35mm in the fact you are dealing with separate components.

You will need to consider getting a body, viewer, lenses, film backs, and a few other accessories. Some medium format cameras come with some of these items already on them.

Formats

There a few choices in negative size film, including the 2¼ Square format camera, the 6x7 format camera, and the 645 format camera. Each of these medium format cameras will work well for you, since you can add lenses and other accessories as you go along.

The 2¼ (6x6) square format camera works well both in the studio and on location. It uses inter changeable backs for 220 or 120 film, and gives you 12 or 24 exposures.

The 6x7 format camera is a workhorse in the studio and gives you revolving inter changeable backs for 220 and 120 film. It offers 10 or 20 exposures.

The 645 format camera uses inserts for 120 and 220 film, which cannot be changed in mid roll. Some 645 cameras, however, use film backs that allow you to change film size by changing backs in mid roll. If you currently use a 35mm, the 645 camera is user friendly to you, since you will have to flip flop on vertical and horizontal shots. This is a great camera for photographing weddings.

Buying a Used Camera

You should be able to find a good used camera for less money than buying a new one. If you choose to buy a used camera, expect to pay somewhere between $1400 to $1700 for a used Hasselblad. You can buy a used Mamiya RB 67 for $1000 to $1200. A used Mamiya 645 can go anywhere from $1000 to $1700, depending on the model (inserts or inter-changeable backs).

Here is a nice way to know what year your Hasselblad equipment was made. Write down VHPICTURES. Now underneath each letter write down 1, 2, 3, 4, 5, 6, 7, 8, 9, 0. Look for the serial number. It will be pre-ceded by 2 letters. Match those letters with the code and you should know how old your back or camera is. For example, RT 3576509 was made in 1986.

Before you buy a used camera, try to find out who owned it. Look for obvious signs of wear on the pressure plate and rollers. If the paint has worn down to the metal, it's had a lot of film pass through it. Look for dents and dings on the body and the back. Look for scratches on the lens. Cosmetics on a used camera is very important. Get a 3 month war-ranty. If you buy from a private owner, insist that you run some film through it before committing to buy it.

Get Familiar with Your Camera

You have to become very familiar with your camera. Using the camera must become second nature to you. This will allow you to interact with your subject. You cannot afford to fidget with your camera and possibly miss a good shot. No matter which camera you own, you must learn to listen to it as it performs.

You have to become one with the camera. Know what makes it work, as well as how it works. You need to learn the sounds it makes as it works for you. When I say learn to listen to your camera, I mean every camera has a distinctive sound when it is working properly. With attention and practice, you can listen to the "sounds" of your particular camera and then you can hear and feel problems when they occur.

You should practice using your camera often just as any professional practices using the equipment of their trade. Learn to load the magazine or back depending on which type of camera you own.

Follow the camera's instruction manual as you practice loading 120 as well as 220 film. Practice unloading and reloading, so you can do it quickly and efficiently as this will be a definite advantage for you in stress situations.

•Practice using your camera often, especially loading and reloading 120 and 220 film.

•Fire any lens that you haven't used in awhile.

It is wise to occasionally fire any lens that has not been in use for awhile. Leaf shutter lenses should be stored in the closed position so that the oil does not congeal on the leaves.

Lenses

You will need lenses to add to the normal lens that is already on most cameras. You should have a wide angle lens and a telephoto lens. The combination of these lenses will allow you to handle most photographic situations.

If you cannot afford to get these lenses at first, you can survive. If you can only afford to add one to your collection, get a 150mm lens. This portrait lens will be used for all of your bust-type photography since a normal lens will distort the subject when you go in tight.

Accessories

There are various kinds of photography accessories on the market. These accessories help you take better photographs and help protect your camera equipment.

Here are a few accessories I would recommend you buy at first; you can always add more accessories later.

A Grip

No matter which camera you choose, you should be able to comfortably hold the camera, the flash, the radio, with the flash above the lens axis. In most cases, the grip designed by the manufacturer of your camera is the best choice. The grip must be balanced to your liking. Try before you buy.

A Tripod

There are so many tripods on the market that it is not always an easy choice. If you use the 645 format, you should look at the ease of going from vertical to horizontal. Your main concern is whether you can see your counter horizontal or vertical (while it is on the tripod) without having to be a contortionist.

Some tripods will not let you flip the head so you can view the counter. I know this doesn't sound important, however you will need to figure which tripod allows you make the fewest moves under stress situations. Take the time to put a tripod through most photographic situations you will encounter before you buy.

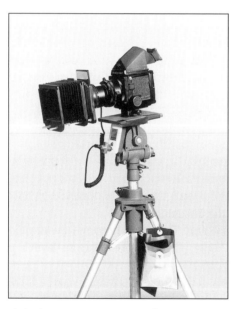

1.1: A camera on a tripod.

Cases

A good case (soft or hard) is needed. Some people still like the hard cases, however the current trend seems to be shifting to the soft shoulder type bags. By using either or both types, you should be able to go on assignment with a camera case, and a light stand and tripod pack.

Electronic Flash

A good flash unit is important. There are many on the market, and all are acceptable. All you really need right now is something like a Vivitar 283 flash, or the Metz 45. These two flash units are what we use at this

time. The trusty Vivitar 283 is amazing, and gives you a lot more security than any other flash I've ever used. The Vivitar is used as an accent light most of the time; while the Metz, which we use as our on camera flash, is a more powerful unit.

The main power source on either of these two types of flash units are Quantum batteries. These are rechargeable high capacity batteries. They are very reliable and can power your flash for an entire wedding. In addition to the Quantum batteries, one can use Nicads and AA batteries for back ups.

It is always a good idea to have two flash units. One can serve as a back up unit. Later, when you learn how to work with an additional flash, it can add to the quality of your portraits.

There are two kinds of photographers. Those who have experienced equipment failure and those who will. Keep your batteries fresh and charged. Always carry back up equipment. Be ready when it is your turn to go into the "I have now experienced trouble" class.

Direct and Bounce Flash

Direct flash goes from the flash head on camera directly to the subject. You can alter the way you use your flash on camera by using bounce flash.

Bounce flash is created by tilting your flash toward the ceiling, thus bouncing the light off the ceiling. When you do this, you are creating a nice soft overall lighting effect.

Getting the correct exposure can be a little tricky, but with today's automatic cameras, it's no problem. Without an auto flash, use $2f$ stops over the direct reading.

Naturally, if the ceiling is too high, don't use bounce light. In some cases, you can bounce light off a wall for another effect. Also, using a white card on your flash will direct some of that bounce flash to the subject, helping put some sparkle in the eyes.

Check Your Sync

Most important of all, you must know if your camera and flash are in sync. Watch out for the older lenses that have M and X settings on them. If you have a lens with these settings on it, fix it so you cannot possibly plug into or switch the lever to the M setting.

You must always check your sync. This must be done every time you go out on an assignment. Some photographers also do it during the job every so often to make sure.

Today, it is easy to be sure your camera is in sync with your flash. Those who have a Polaroid back merely fire off a test shot. Those who do not have a Polaroid back camera can check their sync by looking through the back of the camera. Setting the shutter speed at 1/60th of a second, the f stop wide open, fire the camera and look for a nice large circle of light coming through the lens.

Studio Lights

Before we explain lighting systems, we need to define the kinds of lighting sources we will be talking about throughout the book

"...you must know if your camera and flash are in sync."

- *Parabolic Lights* use the flash tube with a reflector to direct light onto the subject.

- *The Soft Box* uses the flash tube enclosed in a light box which bounces the light inside the box as it directs the light through a translucent front panel onto the subject.

- *The Umbrella Light* uses a flash tube bounced into an umbrella which produces a non directional light onto the subject.

Most manufacturers of lighting systems sell entire light systems complete with lights, stands, power supply, reflectors, and a case. That is the best way to get started. Pick a well-known brand with which you can grow. Make sure you buy lights with modeling lights that will give you the light in accordance to the flash output you are using. If you are going to learn to "write with light," you must be able to see the light.

Self Contained Lighting Units (Power Lights, Mono Lights)

These are a very popular source of lighting for studio and location photography. Self contained means everything needed to power that flash is in the flash head. These strobes have the option of being triggered by the camera shutter and/or by its own built in photo cell. A photo cell is a light sensitive device that triggers the flash in that unit when another flash fires. The beauty of these lights is there are fewer cords on the floor. Only one light has a shutter cord, and there is no power pack on the floor. All the other flash heads are being fired by their respective photo cells.

They do, of course, each have their own modeling lights which can also be dialed down in the same increments as your flash. Some have little bells or lights which let you know if one of the lights has misfired. And if you are a computer person, some lighting units offer a control panel, allowing you to set the power to all of your lights right at the camera. I find these types of lights very convenient and reliable.

Lights with Separate Power Packs

When you purchase this type of lighting system, you will need to buy a power pack first. You need to be sure what kind of photography you will be doing, since this power pack will be supplying the power to all of your flash heads. Although you can get by with a 400 watt second power source, I suggest getting an 800 watt second power pack. It's important that you pick a model that you can build on later.

The Light Heads

The next items to purchase are the light heads. For the four light system, a common lighting configuration, these would be: 4 lights — two with sixteen inch reflectors (or umbrellas, or soft box) and two with five inch reflectors. They will be used as one main, one fill, one hair, and one background light.

The best way to buy these is as a complete lighting set sold with everything you need to get started immediately, including a case.

CHAPTER TWO

Basic Lighting

As we go into this lighting guide, it is important for you to understand my lighting philosophy: I keep it very simple. In the chapter on photographing seniors, I will be more specific as to how we light and the equipment we use.

Techniques

Lighting should be kept as simple as possible. There should only be one basic source of light. This is called the main light. Any source of light added after the main light should only enhance, not destroy.

The fill light does just as its name implies. It fills in the harsh shadows that the main light will create. If the fill is used correctly, you will not know it was involved. At least your customers won't. The fill light enhances but does not destroy the modeling the main light has created.

The hair light and the background light are also lights used for enhancing. There are various lighting techniques; some of the most important ones are as follows:

1. Broad Lighting

2. Short Lighting

3. Butterfly Lighting

4. Profile Lighting

5. Rembrandt Lighting

6. Split Lighting

Broad Lighting

The side of the face turned toward the camera is fully illuminated. If your subject is seated with the face looking away from the main light, this is broad lighting. The shadow falls on the side farthest from the camera.

"Lighting should be kept as simple as possible."

2.1 (upper left):Broad lighting.

2.2 (upper right): Short lighting.

2.3 (lower left): Butterfly lighting.

2.4 (upper left): Profile lighting.

2.5 (upper right): Rembrandt lighting.

2.6 (lower right): Split lighting.

• With butterfly lighting, the shadow should not go into the lip line.

"Each light you use...has a specific function."

Short Lighting

This is my favorite type of lighting. The side of the face turned away from the camera is fully illuminated.

Butterfly Lighting

The main light is placed directly over the camera lens at the same height as you place any of the other lighting. The shadow you see under the nose resembles the shape of a butterfly, giving it its name the butterfly light. Please note that the shadow should not go into the lip line.

Profile Lighting

The body is facing full front or full back while the subjects head is turned so the face is looking off to one side. You can use a front profile or a back profile. The main light is positioned at about the subject's nose, causing a shadow on the side of the face facing the camera.

The main light should still be the same distance from the camera as the rest of the shots. You want to get a triangle of light on the cheek facing the camera. When doing profiles, they should be just that, a full profile. A good tip here is for you to make sure no part of the other eye is visible, other than maybe an eyelash.

Rembrandt Lighting

This lighting is a variation of the short lighting and the butterfly. The main light is placed on the side of the face turned away from the camera. I look for a triangle of highlight on the subject's cheek away from the main light. When done well, it presents an elegant portrait.

Split Lighting

The main light illuminates only one side of the face, leaving the other side in shadow. This is not an easy lighting technique to master.

The Function of Each Light

Each light you use when taking a photograph has a specific function. When you understand the function of each light, you can better learn how to see light and create your own photographic style.

The Main Light

The main light is usually used about 45° to one side of the camera. The distance of this light is usually anywhere from five to six to feet from the subjects face, depending upon the power of your flash unit and size of reflector or soft box being used.

A good rule of thumb relative to where to position this main light is to look for the catch lights in the subject's eyes. Those catch lights should appear at ten or eleven o'clock, or at one or two o'clock, depending on what side you are lighting from. I personally prefer the 10 o'clock, and 2 o'clock scenario.

The Fill Light

This light is set up close to the camera, and as close to the lens as possible. This light should be a larger light source than the main.

The 3 to 1 Light Ratio

What is a Lighting ratio? Ratio numbers are confusing. Remembering that the main light only illuminates the highlight or brighter side of the face will help you with the numbers. The main light does not illuminate the shadow side of the face. On the other hand, the fill light does illuminate everything that the camera sees.

Therefore, the light ratio is expressed numerically in terms of the total amount of light falling upon the highlight side relative to the shadow side. The light ratio you should strive for is 3 to 1.

To achieve this ratio, place the fill light one f stop larger than the main light. Another way to achieve the 3 to 1 ratio is, if the main reads $f11$, to place the fill light so it will read $f8$. Or still another way, assuming you will use two lights of the same power, is to place the main light five and one half feet from the subject, then place the fill light eight feet from the subject, then you will have a 3 to 1 ratio. Some photographers like to put some diffusion over the fill light, giving it a softer shadow line.

If your meter won't work, remember: guide numbers are forever. As a professional wedding photographer, you should know the guide number of your flash unit relative to the film you are using. Divide the feet your flash is from the subject into your guide number and you will have your desired f stop for your flash and that film.

The Hair Light

Place this light on a stand with a boom approximately five feet above the head and behind the subject. This light should be set up so it does not illuminate the forehead. The idea is to merely skim the hair, rather than pounce on it. Use a five inch reflector with a snoot for this light. (A snoot produces a small circle of light.)

The Background Light

Basically, this light is a small light, with a five inch reflector used between the subject and the background and aimed at the background. It serves primarily as a separation light, giving the background some depth. The background for bust type portraits should be about five feet from the subject, which allows you to put the background light between the subject and the background.

With the use of a gel over your background light, you can alter the color of the background. A Gel is a piece of heat resistant transparent plastic material that comes in sheets of various colors. Gels give you a way to color coordinate the background with the subject's clothes.

Punch and Kicker Lights

A punch light is merely an accent light (a smaller source of light) sometimes used to "punch" up an area that you feel you would like to emphasize.

A kicker light can be used to subtly bring in a light from the side to add another light source.

Do not use these last two lights until you can correctly add them to the mix. Stay with the four light set up and you will stay out of trouble.

2.7: Hair light with snoot.

2.8: Fabric is hung on a velcro strip and highlighted with a background light.

"Learn to use your lights with the standard four light set up."

Using Your Lights

Learn to use your lights the with the standard four light set up. Use them often. Use them the same way every time until you know exactly what they are capable of doing in the situations in which you will be using them. Once you are capable of coming in with consistently good exposures, then and only then, should you do some experimenting.

Concentrate on the basic rules of lighting and learn to see light. You should be totally aware of what your lights can do for your photography. Once you do that, the camera in your hands can be every bit as creative as the brush in the hands of a talented painter. You will be limited only by your imagination.

Lighting in My Camera Room

The camera room, which is 20x24 feet, is set up so I can shoot both full length and busts without moving any lights. Full lengths are shot on one side and bust type shots on the other.

The Full Length Side

The fill light is two 42 inch umbrellas which are positioned on each side of the camera 10 feet from the subject. They are hung from the ceiling with picture hanging wire. They give me an f8 reading and since they are a fixed fill, I always get the same reading on the fills.

The main light, one 16 inch parabolic, is on a stand approximately 7 to 8 feet from the subject. It becomes the main light, and remains there. This light is diffused a bit. Diffusion over your light gives you softer shadows with broader coverage and slightly less contrast. Set that light up to get an f11 reading so you can stay within the 3 to 1 lighting ratio. The cords to all of these lights are hung from the ceiling.

Background lights are two Flashmaster lights. They are positioned on the floor, one on each side of the background, which serve as background lights on the high key shots. These two lights assures you of a

2.9: One of two umbrella fills used on the full length side of the camera room. They are both hung from the ceiling.

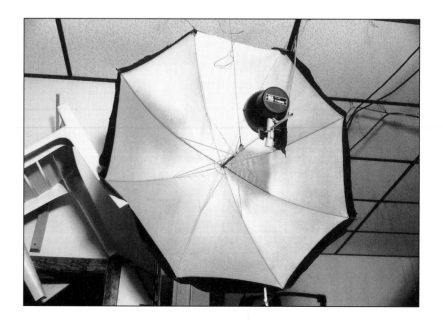

2.10: Here is an example of a high key photo taken on the full length side of the studio.

2.11: The spotlight.

true high key effect. High key means that your background is basically all white. To achieve this effect, you blast the white seamless background with approximately four times the light that you are using on your subject. There should be no horizon line on these shots.

Top lighting is two Speedotron ceiling lights with 9 inch reflectors. These are bounced off of the ceiling to provide separation and hair lighting for our full length portraits.

The spotlight provides a pattern on a background. These patterns are created by cookies which are inserted into the spotlight. These metal cookies come in various shapes, providing creative and fun patterns that add a little spice to your photographs. They can be purchased from the makers of the spotlights or you can make some yourself.

Summary

On the full length side, two umbrella fills (hung from the ceiling) give a reading of f8. That never changes. So your f stop never changes either. The main light, which is already on that full length side, on a light stand, is positioned so you get an f11 reading, giving you a 3 to 1 ratio.

2.12: This is the basic lighting set up on the bust side.

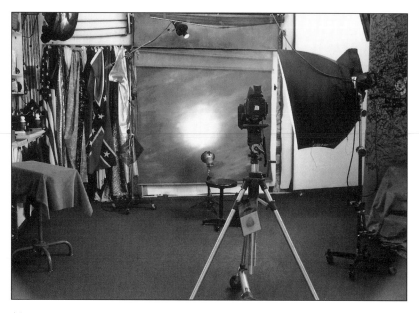

The Bust Side

The main light is a lite dome medium soft box on a light stand.

The fill light is a Lite dome large XTC soft box hung from the ceiling facing the bust side. (All cords are hung from the ceiling.)

A hair light is used with a 5 inch reflector and a snoot on a stand with a boom. A snoot is an attachment that fits over the reflector and makes a small circle of light when it lights the subject's hair.

A background light is used with a 5 inch reflector and a grid. A grid is an attachment which serves the same purpose as a snoot but it gives softer edges.

In the bust area, a large XTC Lite dome soft box hung from the ceiling serves as the fill light with an f8 reading. The main light is a medium soft box on a light stand positioned so that it will give a reading of f11, the result being a 3 to 1 lighting ratio. All of the mains, fills, hair and background lights are triggered by a radio device on the camera. A radio device is a triggering mechanism plugged into the shutter, tuned to a radio frequency picked up by a receiver in the camera room. Any other accent lights, such as high key background lights, full length ceiling bounce lights, and the spotlight are all fired by photo slaves. Photo slaves are the same as photo cells and can be plugged into each power pack on an individual basis.

Since we are primarily senior photographers and because all of the senior portraits are taken in the studio, we need to have the lights and cords up and out of my way in order to move 1500 seniors through there with a minimal amount of light stands to move and no cords on the floor. This camera room was designed so that we could do as many students as I could personally photograph and still put out a quality product with as much variety as could be brought into each sitting. To emphasize the secret to consistent quality is a minimal amount of light movement.

CHAPTER THREE

General Portraiture

Now that we have gone into our basic lighting set up, lets get a bit more specific relative to what you will encounter relative to portraiture.

Poses

- *The Bust Pose* (also called the head and shoulder pose) is truly what it implies, a view showing the upper body from the just above the waist. This pose is still the most often used pose in our business.

- *The Three Quarter Length Pose* shows the subject from the knees up. It can be used while the subject is standing or seated in a chair. This pose is used in many executive type sittings and, of course, in bridal photography, and on most of our senior sittings.

- *The Full Length Pose*, as the name dictates, views all of the subject.

Photographing Men

There are slight differences when photographing men as opposed to women. The lighting pretty much stays the same, but the backgrounds and poses can vary more for women than men. A man just wouldn't look quite right with his hand on his shoulder, his head dreamily looking off into the distance. Of course, most men get their picture for business purposes, so a straightforward bust type photo is usually what men want.

Lighting

You do not need to change your lighting too much, so no matter what type of sitting you are working on, your main light should be a parabolic or a Lite Dome or an Umbrella.

My main light is the medium Lite Dome XTC soft box. Place it about five feet from the subject or whatever it takes to get an $f8$ reading on the

"There are slight differences when photographing men as opposed to women."

3.1: An example of a man's portrait using the bust pose, while including his hands resting on the posing table.

•Gauge the height of the stool based on the trunk of your male subject.

highlight side of the face and about two feet on one side of the camera. The distance is about five feet.

For the fill light, we use a stationary XTC large Lite dome soft box hung from the ceiling. Stay with the 3 to 1 lighting ratio, no matter which type of fill light you use.

Setting Up

Assuming you have all of your lights in place, have the man sit on an adjustable stool. You will have gauged at what height to set the stool based on the trunk of the man. To make sure the stool is at the correct height, set the stool height at about the mans knees while he is standing. In order to do good clean portraiture, you must concentrate on the subject. By that I mean, once the subject is seated, look at the face to decide where you will place your main light, and then, most important of all, check out his clothing.

Clothing

Make sure the jacket has not pulled away from the shirt collar. A good way to insure that this will not occur is to take hold of the front of

3.2 (upper left): A bust type pose that includes the hands.

3.3 (upper right): A typical bust type portrait.

3.4 (right): Here is a bust type portrait using the back of a chair to pose the hands.

3.5: A profile pose can be used for some male portraits.

the jacket right at the front top button while he is standing, and then ask him to sit as you hold on and pull down on the front area of the coat. Check for lint; use a lint brush if needed. On women we have wrinkles in the clothing, not acceptable; however on men we call them folds. Folds are allowed as we can arrange them to our liking.

Look at the collar for abnormalities. If it is an adult, chances are that the shirt will fit. That may not always be the case on seniors. Here is a little trick for a kid that comes in with a shirt collar way too big. Nip in the back with a clothes pin or any clamp. Now you have instant collar correction. Straighten the tie, even if it does not need it. This makes you look knowledgeable and proves you are concerned.

•If the shirt collar is too big, clamp it in the back with a clothes pin.

I have my own way of posing men with double breasted suits. Ask them to unbutton the jacket, then sit them down. Now arrange the coat in double breasted fashion and have the guy put his finger or hand right where the button would be. You can also adjust some coats by using the clamp method.

The moral in all this is you really have to look beyond the lighting. Learn to look through the subject. At his clothing, the background, and

"Most males don't want you to fuss too long."

everything that is involved in the final result. Do it with haste, if you wish, but do it. Most males don't want you to fuss too long. On the other hand, if you are in a noticeable rush, they can hang you for that also. My feeling on the subject of speed on male portraiture is haste is better than fussing too much.

Other Things to Watch For

As I have mentioned before, I will shoot almost everyone with the same relative lighting, favoring the short light method for most males. I prefer the shadow side of the face to be closest to my lens. Since many men have rather round chubby faces, using this type of lighting thins the face somewhat.

If your subject has two chins, have him stick out his chin in an effort to tighten the area under his chin. Throwing that area in shadow will be a big help. To do this, lift the main light a bit.

If you notice a thinning of the hair, or hardly any hair on the head, do not use a hair light. You can try to minimize the lack of hair by attempting to blend the head into the background. (Lower the intensity of the background light.)

If he wears glasses, keep the main light up a bit higher so that it does not reflect on the glasses. Make sure that those reflections, which are usually there anyway, don't get into the eyes. You can go to all sorts of weapons for eliminating glass glare, but in some cases it's going to be there anyway. Do your best by keeping it to a minimum and making sure it is confined to the area outside of the eyes, off the glasses if you can, and then let your lab do the rest if you feel it is necessary. Labs can do glass glare spotting and retouching for a nominal fee if you need it.

Masculine Poses

When photographing men, always try to think in terms of masculine poses. An example of a non masculine pose would be having the man tilt his head to his high shoulder. A man generally looks more masculine when his head is somewhat tilted to his lower shoulder.

As far as poses in general are concerned, the usual head and shoulder poses will do very well. If you wish to go beyond the head and shoulders poses, you may use the three quarter poses.

Use a nice chair with arms or a posing table so that he can have a place to rest his elbows. Depending on his profession, you may wish to place a book or other prop in his hands. It is a good idea to place a low stool or box in front of his feet. Place the closest foot to the camera on this elevator, then place his hand on the knee, which his already slightly higher than the other. Have him place his elbow on the knee which is propped up. While in this position, move the box to the knee furthest from camera, and put his elbow on it. With the movement of this low box, you have given yourself a few more options during this sitting.

Summary

Now to make sure we understand the basic posing procedure, let's go over a quick summary of what we do. If you are going to use a ten exposure back, go for five poses from each side of the face. Concentrate

3.6 (upper left) and 3.7 (upper right): These two shots are examples of leaning the head one way while having the eyes looking at the camera.

3.8 (left): This is an example of an over the shoulder pose using a fabric background.

on posing and expression. Contrary to what you may think, use a softening filter on all of your portraits, except for full lengths. A softening filter fits over the lens. It takes the edge off the sharpness of the lens as it subtly blends highlights and shadows, producing a ever so slightly softer image. These filters come in varying degrees of diffusion, or softness, and can be used to create some very fine soft lens portraiture.

Hair light: yes, but not on subjects with thinning or no hair. Fill light: yes. Background light on a low power. Please remember, keep your lighting and posing simple. Your subject will appreciate it

Photographing Women

When photographing women, you generally have more choices when it comes to posing and backgrounds than you do with men. You can also vary on the lighting set up a little. As with all clients, make sure you know what the purpose of the photographs will be.

Lighting

For the main Light, go with the soft box most of the time, although feel free to light with a parabolic, and for more punch, try the spotlight.

3.9: This is a bust type pose with the hands showing. It's also an example of backlighting the hair.

3.10: A profile pose using the profile lighting set up.

"The use of gels will let you alter the color of your background."

The hair light is always used. The background light is also always used and occasionally you can back-light her hair. This is done by turning the background light toward the hair of the subject. Place it about two feet from her and at the height of her head. Fire off a few test flashes to be sure you are getting the effect you want. You can also use gels to alter the color of your background.

Poses

Starting with your basic poses, give each woman at least ten head and shoulder poses. Photographing women affords you the luxury of having many more options on posing. In addition to the above, you can do some over the shoulder poses. Never allow the nose to go out of the face as you do three quarter face views. One of the problems you may encounter on these over the shoulder poses is the neck lines sometimes caused by the turning of the head.

You should also add a few profiles to this session. Do both a front profile and a back profile. The main light gets moved on this profile type pose by bringing it along and lining it up with the nose. For an

3.11 (upper left): Here is an over the shoulder pose. A fabric background is used.

3.12 (upper right): When posing women, there is more options than with men. You can use different hand positions to create a variety of poses.

3.13 (right): This photo, using a fabric background, shows another posing idea you can use when photographing women.

3.14 (upper left): A three quarter length pose of a bride.

3.15 (upper right): Here is an example of a full length pose of a bride with a spotlight creating the window effect.

3.16 (left): A three quarter length pose with a window insert and spotlight used for the background.

easy way to remember, I offer another Giolas rhyme "where the nose goes, the main goes." The main light should travel to an area in line with the nose and just a bit behind the subject, so there is a highlight on the cheek closest to the camera. We are talking about a radius, since the main light is still the same distance from the subject, as it is on all of our basic poses.

More poses on women can include using an adjustable posing table. You can cover this table with cloth in keeping with the overall hue you are using in your background. This posing table, by the way, is another item you need in your camera room. These poses include the hands, so it is important to remember that only those subjects with made up nails are suitable for these shots. You do one with the elbow on the table and the hand extended, so the fingers reach gently to the chin.

Another in this series can include the palm of the hand cupped under chin, or in a variation of this style, use both hands up to the chin.

One of my favorite poses is to have the woman turn her head to the high shoulder as if she was looking off camera, but ask her to keep her eyes on the camera, which puts most of the emphasis on the eyes. This pose sells well.

Backgrounds

In addition to using various posing and lighting techniques on women, you can vary the background much more than with men.

You can use many fabrics in your backgrounds, as you match the background with the mood you want to convey or the subjects attire. By keeping the fabrics far enough back of the subject, you will have them out of focus enough so they are not so easily defined.

Covered Foamcore board is another good system for having many backgrounds at your beck and call. These are light weight 5 feet by 5 feet boards that are covered with fabrics or metallic foil (see chapter on seniors). You can also use gels to coordinate the background with the color of the subject's clothing.

Photographing Brides in the Studio

I love working with the bride in my studio. This takes place approximately two weeks before the wedding at the studio.

I prefer doing these sittings in the evening, when we are closed. It will be you, the bride and her mom most of the time. Again, use your basic four light lighting system.

Setting Up

For brides, you need to back up just enough to include her flowers as they rest on her lap. Make sure you sit her on the adjustable stool so her legs are at least in a slightly downward position.

In other words, if she looks like she is sitting on the potty, please raise the posing bench just a bit. She should have her feet resting on the ground or an elevator of sorts so that she will have a lap on which to place those flowers. It is a safe plan to make sure you get enough of the basic poses before you begin to create.

"...you can vary the background much more than with men."

3.17: A profile pose of the bride in the studio using the profile lighting set up.

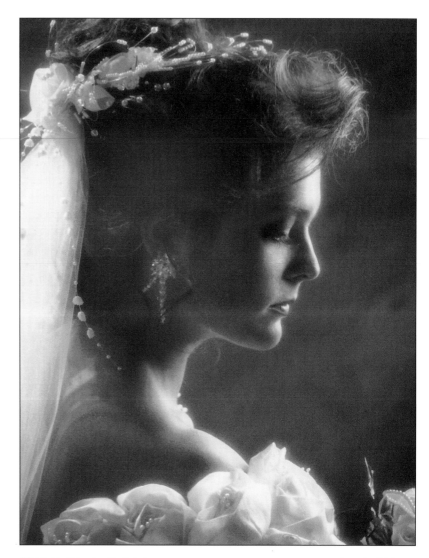

Poses

Brides offer you a splendid opportunity to do some over the shoulder poses. You will find that some brides have more flexibility than others which, for the latter, limits over the shoulders photography. Always make sure the nose stays within the face.

When doing this pose, turn the shoulders so that the back of the gown shows. Avoid shooting straight into the shoulder which will really stiffen the look of your portrait.

The three quarter face view allows you to have the bride looking off camera, at camera or down at her flowers. At any time you can throw in some heavy diffusion to create a soft lens effect. You may tilt the camera ever so slightly, to come up with another adaptation of the same pose. Make sure that you do most of these poses from both sides unless, of course, you have noticed a definite flaw on a particular side of her face.

From here go into profiles. Profiles and I get along very well. However, make sure you do not do a profile of a bride that has a problem nose. On the profile poses of brides remember the rhyme: "where the nose goes, the main goes."

•To create an adaptation of a pose, very slightly tilt the camera.

The only problem that is not dealt with previously is the veil. It will hassle you a bit when you try to do your profile and three quarter face view poses. I think the best advice I can offer is to either let the veil be a background for the face and nose, or push it back so it does not cut through the nose and face.

The posing of the gown is not nearly as much trouble as in full length poses, however, it does require some planning. Have the gown flow outward from the posing stool and, in order to create this effect, you can tape the gown to the floor. Or if you can sew, get some fishing weights and sew them on to a piece of Satan and let that hold the gown down. You can put every fold exactly where you want it by using just a bit of tape or any item that will hold the gown in a certain position.

Learning to pose the flowers correctly is necessary. You can learn this by watching the florist. I have always made good friends with florists, therefore it is easy for me to get an education from them.

Full Length Bride Poses

Posing the bride is an art in itself. Again, I take the simple approach. Walk over to where she is standing, gently hold her hands and her

3.18: Here is a full length pose using a spotlight for the window effect on a low key background.

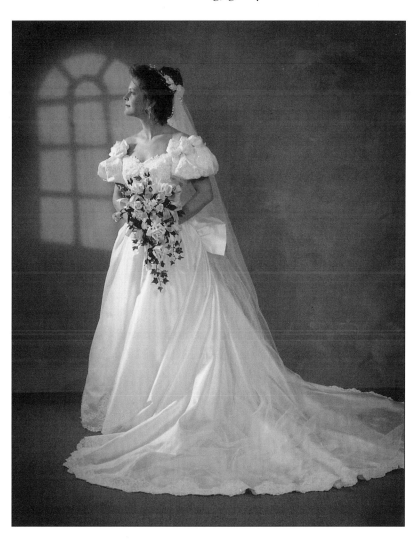

flowers as you lead her to the posing position. When she is in the proper position, begin to give her instructions on how to position her feet. Use the basic modeling pose No.1. The foot closest to the camera is placed in front of the other. The back foot is where you want the bride to place most of her weight, as she bends her front leg slightly. If you tilt her head just a little to the high shoulder which should be her left, you will see the famous S curve us "old timers" always talk about.

When posing the bride, you will have to pay attention to the arranging of the gown. Check out your local bridal shop. Look at all of the magazines, and it goes without saying, attend some programs on bridal photography. You have to be automatic when it comes to handling all of the gowns you will be confronted with.

Photograph the bride from both sides, turning her as you rearrange the gown each time. Have her looking at the camera and away from the camera. Do front profiles and back profiles on the full lengths. And, of course, the main light still follows the nose of the bride.

You can get artsy by bringing in the spotlight which will create some interesting effects on the background depending on which cookie you use. The spotlight and an assortment of cookies are definitely a nice addition to your camera room.

Keep in mind that every movement of your subject requires a re-arrangement of the gown, as you go from the basic fronts poses to the three quarter view poses and the profiles. Lighting wise nothing really changes from what we have done on the short side of the camera room. What does change is the fact that you have to pay strict attention to the gown. Also you will now have to pose hands and flowers.

Make sure that the bride's waist always shows. By lifting the elbows away from the body, you will look for he opening between waist and arms. If you do not do this, it will make the bride look a lot heavier.

3.19: You can also use more casual poses when photographing brides in the studio. This bride is seated on a muslin background.

Left: A three quarter face view using diffusion on the lens for a soft focus effect.

Below: A portrait using a kicker light coming in from the left side.

Left: A study of an Orthodox Priest.

Below: The Professor pauses to light his pipe.

Left: Here's an example of a bride and groom environmental shot.

Below: When photographing on location, keep the lighting simple.

Left: Here is a full length pose using the muslin backdrop.

Below: A portrait of a bride showing the over the shoulder pose.

"Make sure the bride's waist always shows."

Have the bride hold her flowers as gently as she can. Avoid the clutch type hold. The flowers should be held just below the belly button for a pleasing look. If you have trouble with her grabbing the flowers, try asking her to place her hands together with fingers slightly interlocked in a prayer pose, as you place he stem of the bouquet just where where her thumbs interlock.

For good reason, use your own flowers when you do the one on one bridal shoot in the studio. If they wish, they can bring their own flowers, however you want the bouquet to be on the small side. You want to photograph a bride with flowers, not flowers with a bride.

You should always do both high key photography and also do the some of the same poses on the low key view Old Masters background. (Low key simply means a dark background.)

Use some diffusion on all the bust type portraits, with heavier diffusion on the mood shots. Do not use diffusion on the full length shots.

CHAPTER FOUR

Weddings

There are many ways to photograph a wedding. How you photograph a wedding could depend on the area in which you live. The following represents the way weddings are generally photographed in and around my town — this may differ from the way weddings are covered in your area. It might be a good idea to do some local research on how a "typical" wedding is photographically covered.

We generally start our wedding coverages at about 2:00pm and go to about 10:30pm. We usually shoot about 15 rolls of 220 film. Our coverages promise a minimum of 200 previews, although we usually show more than this.

Equipment

When shooting on location, you must make sure your equipment is ready to go. Having back ups along is strongly recommended. The day before you go out to cover a wedding, check out all the equipment and have it packed and ready to go. The day of the wedding will be hectic so take some time to get organized the day before.

Camera

The camera used is a Hasselblad. Some of the photographers who have worked for me used the 645 format, which has always been ok with me. Frankly, I believe the Mamiya people made that camera for the wedding photographer.

Lighting

The portable flash unit is the Metz 45CT on camera powered by the Quantum high capacity battery, and the 283 Vivitar off camera, also powered by the quantum battery, and both are triggered by a Quantum radio.

At the altar later, when allowed to do bridals, we set up two Speedotron M-11 brown line lights as the main illumination, with the 283 flash unit used as a punch light. If we feel that we need more light, due to a large group we sometimes turn on the Metz on camera.

"Having back ups along is strongly recommended."

•Keep the lighting as simple as possible when you go on location.

While on location, make sure the lighting is very simple. With a set up like this there are a lot of ways to bail out if one of your flashes does not function. It is like having back up equipment available to at least get you out of a jam with saleable photography. The Metz on camera can do a good job all by itself. Even that trusty little 283 can work alone if needed. If you own only one flash with some power, you can do an acceptable job on a wedding. You should carry back up units. However, you won't have any back up equipment when you first start out, a 35mm will help you out if needed as well as a smaller flash unit. At any rate, it is not critical that you even use a second light. What is critical is that you get those poses and get those expressions. That is what really sells.

An Assistant

You can choose to work with an assistant on all of your weddings. This assistant's main duty is to be in the proper position for the second flash at all times. In addition to double lighting, the assistant must watch for blinks, and be the brides helper, as he or she anticipates the photographers next move.

Photographing at the Home

If you are asked to start at the home, you will need to line the session up at least one and one half hour before the ceremony. Only the bride and her family plus the bridesmaids are included in this session. During this session, you do the usual home type bridal photography:

1. Bride with mom, in the mirror
2. Bride with maid of honor in mirror
3. Bride posed with bridesmaids
4. Bride with dad
5. Bride with family
6. Bride with Grand parents
7. Bride alone — look for a nice window
8. Bridesmaids alone
9. Flower girl with bride
10. Relatives with bride
11. Special requests by the bride

You can vary these shots as you create some of your own, but watch the clock, and get them to the church on time. Although we have a photographer and an assistant cover our weddings, it is not a problem to cover your weddings alone. You go into the home with flash on camera and another flash held by the assistant. If there is no assistant put the second flash on a stand, using a good photocell or radio to trip that

4.1: The mirror shot taken in the home with the bride and her mother.

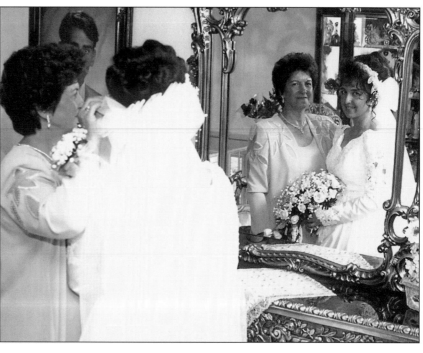

4.2: Another photograph taken at the home with the bride and her brides-maids. A chair and one of its arms is used for posing the shot.

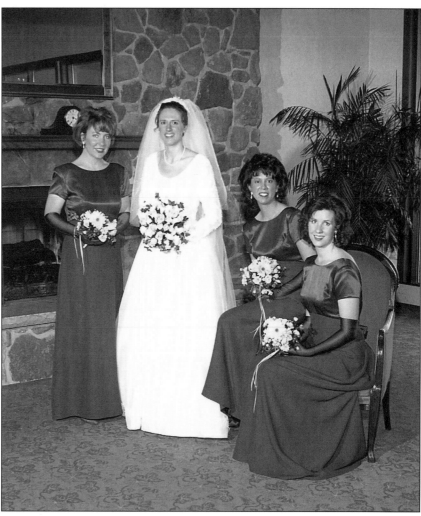

flash. Let the flash on camera provide the actual exposure, therefore we set that flash on auto, (it is a more powerful unit) and we put the 2nd flash on auto also. This frees up the photographer to concentrate on posing and expressions.

Feel free to experiment to find what works best for you. So work it out your way and once you settle on how each light will be used, do it that way all of the time. This way you can be consistent, comfortable, and confident, thus allowing you to concentrate on posing and expression. With the exception of knowing how to get a proper exposure, any extra time spent thinking of light placement is time taken away from where the money is...expression, and posing.

If you need to, you should work from file cards of all the poses you want to do. This is a good idea until it becomes automatic. As you begin to leave each location check your cards to see if you skipped a shot. Finally, as you leave the home, go back and look around for any equipment, you may have left behind. Use your case to tell you something is missing. By looking at your compartments you can see at a glance if something is not there.

Photographing at the Church

As soon as you get to the church, set up your tripod with your second camera to be used for the balcony shots. This is a good time to get a meter reading for the long exposures that you will have to take during the ceremony. Meter went south? Forgot it at the home? No problem! "Four by Four" will bail you out. ¼ second at $f4$ works most of the time.

Your first priority is to find the minister, priest or rabbi, and make sure he knows you are professionals and are here to obey his rules. If he says no flash, you tell him if he sees a flash during the ceremony, it will not be yours.

Locate the groom and his men, for the requested shot of the groom and the best man. Photograph the groom and his men quickly, so you can concentrate on the wedding processional, which will be starting soon. My biggest fear is not getting to the church on time. Second to that is the fear of blowing the shot of her and her dad coming down the aisle. For this reason, I insist that our photographers photograph the bride and her dad standing there getting ready to come down, plus the one of her coming down the aisle. If I was photographing the wedding, I would take a few more too. Paranoid? Maybe! But weddings are pure pressure, and I like to stack the deck in my favor whenever I can.

The Isle Pictures

We photograph all of the people coming down the isle including the parents. For these shots, should learn to use the zone focus system. Focus on a pew four rows ahead and when the Bridesmaid hits that zone, fire. Pews are three feet apart, so three times four is twelve feet. Set your distance scale on twelve feet and fire when the subjects hit the right pew.

While the ceremony is going on, set up your lights in the back of the church so you will be almost ready to go to the front of the church as

"This is a good time to get a meter reading for the long exposures..."

4.3: Here's an important shot that can't be missed at the wedding. Use the zone focus system to capture the bride and her father walking down the isle.

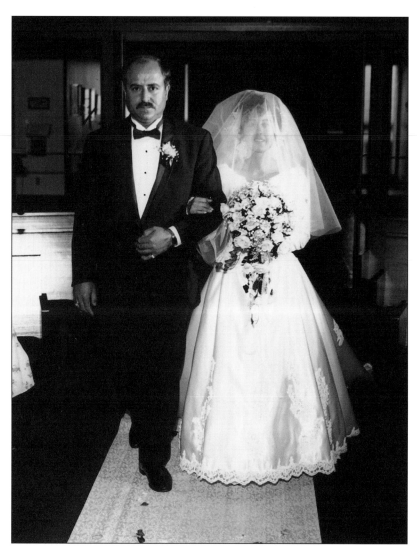

soon as the ceremony is over. During the time that the photographer is getting candids of the receiving line and doing the car shots, the assistant is putting the studio lights up for the bridals. When done with the candids, you will begin arranging the bridal party, with no lost time.

Posing Wedding Bridals at the Altar

After the ceremony, invite everyone to be seated in the pews and tell them you will call them up to the altar as they are needed.

First you want to do the wedding party. First pose the bride and groom. At that point, you tell them they will not have to move for the entire session as you add and subtract the necessary people to do all of the bridal groups. Let the bride and groom know what you expect of them and then get started. Now you can bring up the entire party at this time. You never have much time, so keep it simple.

Begin by placing the bridesmaids on each side of the bride and groom. This allows you to place the men in the back row in the gaps, and any flower girls, and ring bearers in the row in front of the bride and groom. Time permitting, you can be more artistic by finding some chairs and come up with a more pleasing arrangement. Use the wide

4.4: *An overview of the wedding taken from the church balcony.*

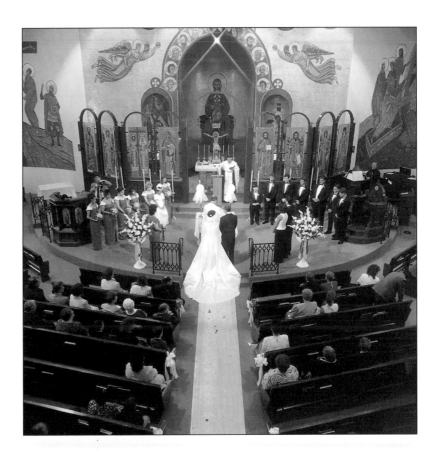

4.5: *An interesting wedding shot taken from the floor level.*

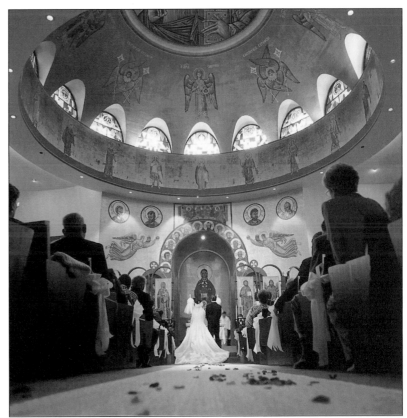

4.6: Here's an example of a bridal party in front of the church altar.

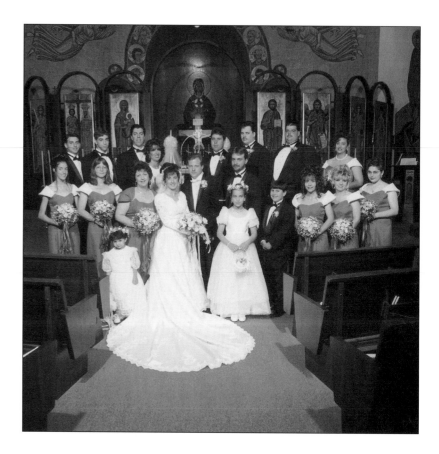

4.7: Make sure to take some photos of the bride and groom alone at the altar.

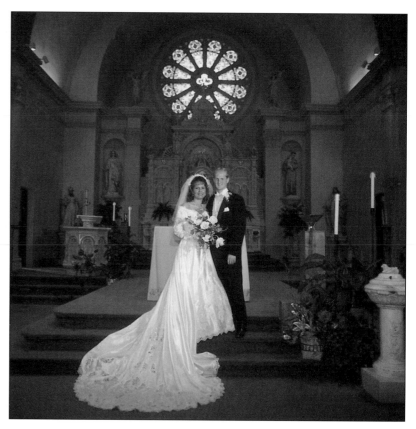

angle lens on your groups, unless you don't own one, then the normal lens will suffice.

For the altar shots, use the camera on a tripod. Begin subtracting and adding people as you go through the series of all the altar shots until you have done the bridal party, moms and dads, families, grandparents, etc. Please note that the bride and groom are still in their original position. If you have done this correctly they have not moved, and are now ready to pose alone for their bridals

After you do all of the bridal party and other groups, you are ready to photograph the bride and groom and follow that up with the bride alone. If time permits and it usually does not, you can do some variations, such as the bride with the maids, the groom with the guys and maybe, some special requests by the bride and groom. You can now do a silhouette, (this pose is set up in the doorway of the church with the photographer shooting from the inside and exposing for the outside light) and finally the car shots.

Bridals at the altar should take no more than forty five minutes. To do this you must be in control! How you get that control is critical and will set the tone for the rest of your day. Actually, if you have presented well at the home, you will have part of the psychology of getting them to like you already out of the way. People will do more for people they like. That must be your goal as you try to be in control! "No control, No goal."

By understanding that eighty percent of all the money pictures will be taken at this time, and unfortunately you are only given twenty percent of the wedding time to do it, I think you will learn to do what is necessary to get things done tactfully in that short time frame.

I must tell you that some photographers will not do altar pictures at all. They do what we call pre bridals, at home, at halls, at hotels, or at the altar, before the ceremony. You may choose to go this route or allow your couples a choice. My personal choice is pre ceremony.

Wedding Lighting at the Altar

For our weddings, we prefer to use a simple safe lighting system, which consists of a 800 watt second power pack and two Speedotron M-11's. You want an f stop of f8 or more, which is why you should strive for affording two large lights with at least a 200 watt second on each. (One flash on camera can work on all of the above and has done so many times.)

Place these lights about fifteen feet away on sturdy light stands that can go up to at least 8 feet both equal distance from the subject, one on each side of the camera. I had a good photographer and his wife doing all of my weddings for fifteen years and among the many things I learned from them was to hoist those lights way up high. We really did not have much time to get very fancy on our weddings but, somehow, this team would come back with beautiful bridal group arrangements. They knew the most important factor in doing well lit groups was don't mess with the lights. Put them up the same way every time and you will know what you are going to bring back. Know what you are doing and do it that way all of the time The key here is consistency on how you do your job.

•**Eighty percent of your sales will come from the altar shots.**

Poses at the Alter

When it comes to poses taken at the altar, you can allocate them as follows:

- Six poses of the bride and groom

- Six poses of the bridal party

- Six poses of the bride alone

- Six poses of all other groups

You should constantly practice all of the poses so you can get your speed up without rushing them. How much time do you have? You must always be aware of how much time there is to work with. Is there a mass? Is it an ethnic ceremony? Will there be another wedding right after yours? Will the priest be rushing you out?

Rarely will we have as much time to work with as we would like. So we must know all of the situations that will or might come up in order

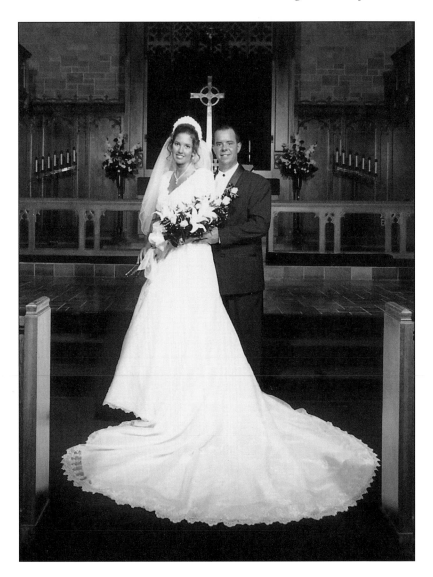

4.8: Altar shots usually account for the bulk of your sales, but you don't have much time to take them. Work fast and efficiently to get all the necessary shots at the church.

4.9: You can vary the bride and groom pictures at the altar. This shot used a flash behind the couple in addition to the front flash.

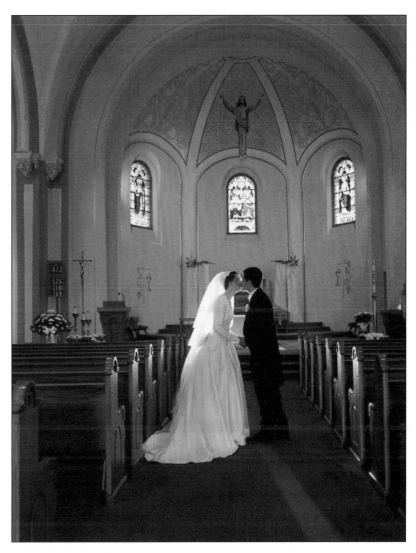

to deal with them. Get all of the allowable shots. As the photographer, you are obligated to do whatever it takes, within the rules of the church, to get all of the shots you must have. This is where the psychology of working weddings comes in.

Wedding Receptions

Wedding receptions are a "fun" places to be, that is for everyone except you. You have to work. By now, most of the important pictures have been taken. Be sure not to leave any formal bridals to be done at the reception. From now on, you will be dealing with people who are primarily interested in being watered, fed, and entertained. Realizing this, you should get as many shots as you can, before the group gets a bit uncontrollable.

Reception Lighting

As soon as you get to the reception, set up a light on the stage (if there is one). It should be at least a 200 watt second unit on a photo cell or a radio and should be aimed at the dance floor area. It is this light

"...get as many shots as you can, before the group gets a bit uncontrollable."

4.10: A shot of the head table at the reception using more than one light to create a better exposure.

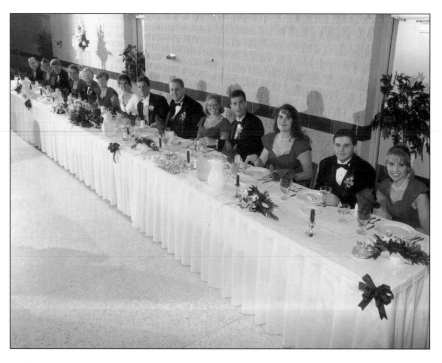

4.11: The bridal dance — one of the must-get shots of the reception.

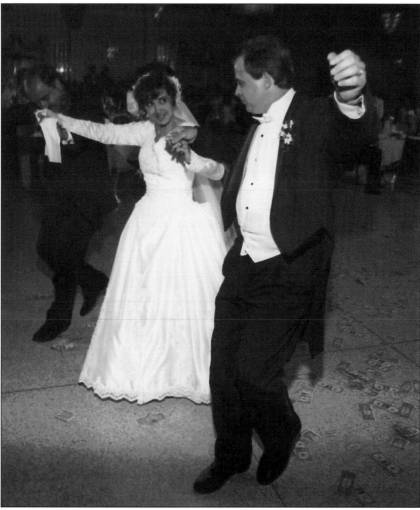

that is going to give you more light saturation on most of your pictures taken in that area as the reception progresses. The assistant should also be ready with the second flash on a photo cell or a radio. Needless to say, the photographer also has the flash on camera

Pictures to Take

Take a overall head table shot. Sometimes you can try using 3 lights to light it. Then do the toast, bride and groom with best man. Do the two family tables, the overall room shot, and be set up to do the cake pictures. As soon as you see the bride put that last morsel of food in her mouth, you should swoop down on her and tactfully tell her that it is time to get the cake cutting pictures. If you have really done your job well, you will have told her this earlier, which makes it much easier to get her cooperation. Using your charm, you convince them to cut the cake. Get the cake cutting over with right away as I have seen the cake fall over on a few occasions.

Cutting the cake is a series of 6 total shots: looking at you, looking at the cake, him feeding her, her feeding him, and two more shots can be taken using your creativity.

4.12: Another must-get shot at the reception is the cutting of the cake.

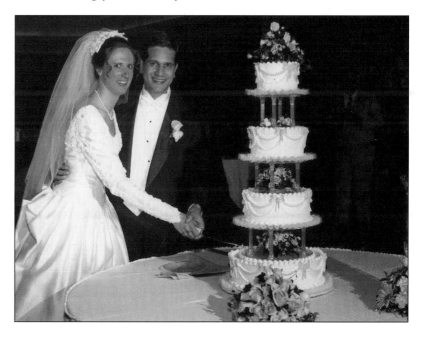

After these pictures, you will prepare for the first dance pictures. Keep in mind that once the dancing starts you won't get much cooperation. The men will be at the bar and the women will be looking for someone to dance with. If you have done your job correctly, all you will have left to do are the family groups some dancing pictures, the bouquet and garter toss. If there is a grand march, of course, you will photograph that, to be followed by the "I love you truly dance." On our receptions, we do not do table group photography. These days you can always tell the couple the video camera person loves to do tables.

When the dancing starts, you need to do all of the necessary dance shots trying to cover the notables but not over doing it! The flash on

4.13: The garter toss showing the groom and the "catchers." Notice light coming from the left as well as the flash on the camera.

4.14: The bouquet toss.

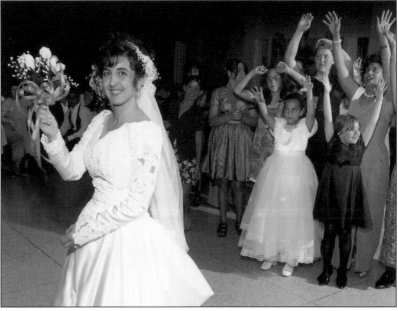

stage and the assistant's flash should be firing as the photographer's flash fires.

After the dance shots, you must talk with the mother of the bride and the mother of the groom, letting them both know that this is the time to do any family, or friends they would like to honor by being photographed. Cover yourself by asking both families. Don't plan on taking group shots any later as getting cooperation is harder.

The Bouquet and Garter Toss

You should start at 9pm to let the bride know that you want to have the bouquet toss at 9:30. You must stay on her case so that it will get done on your time schedule. Again, here is where your personality

comes in. You have got to get her to do what you want yet make her think it is her idea, or at least it is in her best interest "You're beginning to lose some of you're guests," works for me, sometimes. What follows now is a series of very fast moving poses.

On the bouquet toss, take a shot of a fake throw first. You want the bride in the foreground, and her catchers in the background. You can position her so the light on the stage helps light the catchers, while the camera flash takes care of the bride.

Now you can do the garter toss. While the groom removes the garter, you can do a few shots. Once the garter is off, line the men up just as you did with the bouquet toss, and take another fake. Now you do the actual toss with the same lighting as the bridal toss.

The final shots are the last dance. "I love you truly" shots and finally, waving good-bye at the door.

Here is a list of pictures that sell at receptions:

1. Family groups

2. Cake picture

3. Bride and groom dancing

4. Moms and dads dancing with each other and the bride and groom

5. The toast picture

Leaving the Reception

By all means say good bye to the bride and groom and let them know that as soon as they get back they should call the Studio. "At that time, we can set up an appointment to have you come in and pick up your preview album." Never say, "Is there anything else we can do for you?" You know you did all that was needed. If you continue to ask that question each time you leave, plan to be there till midnight. Say good night and leave.

If you have done your job well, they will thank you as they tell you how they can't wait to see the pictures. The film isn't even developed yet, but just by the way you conducted yourself they know the pictures will be great. Sure you got paid, but praise and gratification also help to make it all worth while.

CHAPTER FIVE

Family Portraiture

This chapter on photographing families takes some of the techniques you have learned in the previous chapters and applies them to learning how to set up groups of people in a pleasing arrangement.

Lighting

The fill lights (or light) should illuminate the group evenly, edge to edge. The main light is merely a punch light, and should be feathered toward the opposite end of the group. The fill lights should govern the exposure. (Two large umbrellas, and one parabolic light are used as fill and main.) I am not interested in a high lighting ratio for family portraits, therefore my lighting is rather flat, causing me no problems with shadows in all the wrong places.

Group Arrangements

Group arrangements can be far trickier than you might expect. Setting up a good family or group arrangement is like fitting together the pieces of a puzzle, or like building a pyramid. Fortunately, unlike a puzzle, there is more than one way to solve this kind of challenge, and still make it work. Arrangement is the key to the whole session.

Plan the Arrangement

The first thing you must do is plan your arrangement. Knowing how many people will be involved and what their approximate ages are is a necessity. The day before the actual assignment, you should spend some planning time drawing up some options on the arrangement of this family. Be ready when that family arrives with your lighting in place and all of your benches, stools, elevators, and risers in close proximity. You are set, camera and lens have been selected, and you are ready to photograph.

When the group arrives, ask everyone who is going to be in the picture to step into the camera room, and line up in the area behind you. This allows you to see the various sizes, genders, and heights of everyone at the same time.

"...how to set up groups of people in a pleasing arrangement."

5.1: A Posing bench comes in handy when doing any type of group shot.

5.2: An on location family portrait. Notice the arrangement of the two families.

Start with one person, or if a husband and wife are there, begin by posing each of them first. The key factor in good arrangements is posing each person as if they were in the portrait by themselves. That is to say, if you were to extract every one from the portrait except one person, that person would be in a suitable pose though alone.

By using two good chairs with arms on them, it is possible pose a family with no other props. Let me give you an example. Put mom and dad in the chairs; put a person on each of the arms of those chairs; put two more on the floor, one on each side of the chairs.

Now you can place people standing behind the two chairs. Assuming you will place five more people in the standing row, you can probably photograph about thirteen people or so, without the use of any other stools.

Rules to Follow

Avoid the rows of corn or ducks in a row look. With the use of your props, chairs, stools, risers, etc., you can position people in such a fashion as to not get that "rows of corn" look.

5.3: Every once in awhile, you'll have an interesting addition to the family arrangement. Here, the family pet was included in the portrait.

5.4: Here is a larger family portrait using the posing benches and arms to create a pleasing arrangement.

•Take a Polaroid of the group first. However, try not to let the family see the Polaroid.

Another principle is try not to have heads all on the same level horizontally or vertically. Put people in between the shoulders of the people in front of them. If you need to raise anyone slightly, use pillows, books or any other device you can to get them to another level.

Take a Polaroid of the group. This allows you to see things that were not easily visible in the camera viewer. Try not to let the family see that Polaroid, since it may be time consuming as they discuss different arrangements and you might find yourself losing control of the group.

Large Groups

With very large groups, you might have to forego the "rows of corn" rule so that you can get everyone in the portrait. Let common sense

5.5: *Larger groups can be done using stools of various sizes.*

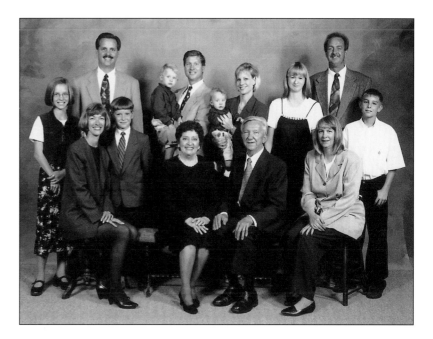

5.6: *Using a riser for the last rows gives a nice, easy arrangement for this choir group.*

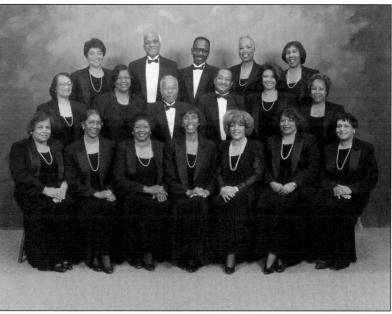

prevail here. Set up a furniture bench which holds three or four people and place as many stools as you own so that they are equally distributed on each side of that bench.

After you fill those seats, use the floor for any person who will sit there. Then you can have a row stand behind those who are seated. If needed, you can bring out risers and put a row on them. Risers are very nice to have. Depending on the width of your background, and of course, your studio, you can get quite a large group done rather easily.

Up till now, we have talked mainly about doing large groups. It really doesn't matter how large or small a group may be, the arrangement is still the critical point that must be learned. Learning group photography arrangements does not happen overnight. The more families you do the

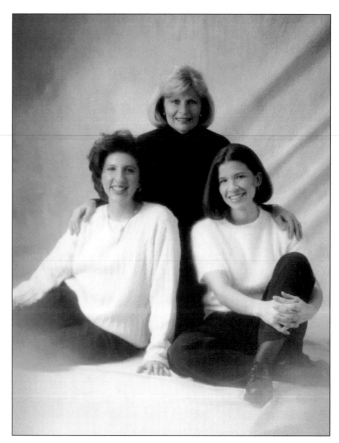

5.7 (upper left): An example of posing a group of 3.

5.8 (upper right): An example of posing a group of 4.

5.9 (left): An example of posing a group of 5.

5.10: Posing a group of 5 in a formal pose.

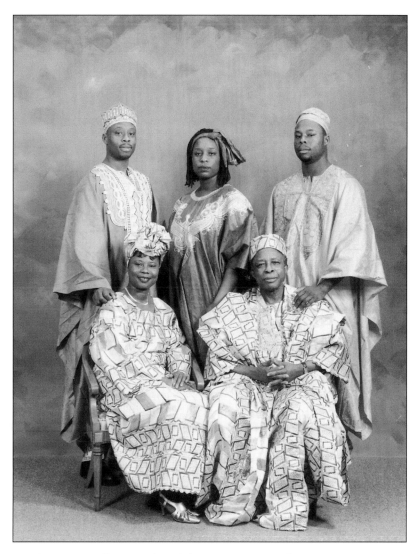

"Stay focused and get the job done."

quicker you will grasp the ability to set up a pleasing arrangement. However, if you do your homework before the assignment, you will find it easier when it gets to crunch time. You will, at times, have to deal with people in the group who feel they know more about posing than you do.

Once in a while a member of the group has an acceptable idea. In this case, don't let your ego get in your way. Go with the flow, gracefully accept the idea.

This is another example of what I mean when I say your personality is a key factor in getting control of large groups. You won't always have control. Stay focused and get the job done.

Working with Smaller Groups

When posing two people, place two stools next to each other, one slightly higher than the other. Ask the woman to sit on the lower stool. Have the man straddle his stool as he sits next to the woman (her back is to him). You should now have two people that have molded themselves into a pleasing arrangement.

5.11: One of the basic bust type poses for a couple.

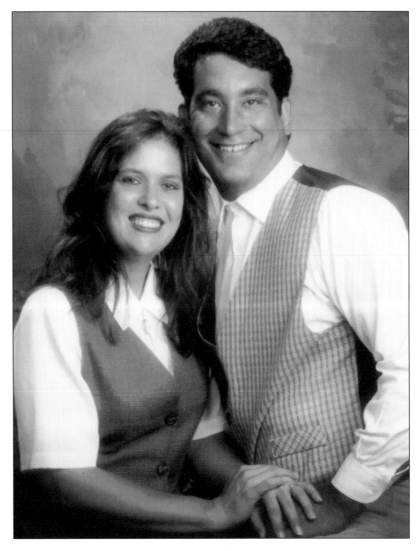

One of the man's legs is in front of the woman and the other leg is in back of the woman. Have the two heads tilt toward each other slightly. It is always a judgment call as to where to place the man's head relative to the woman's head. A good rule is to have is have the man's nose in line with the woman's ear.

This pose can be changed by rearranging the woman so that she is turned toward him with their back shoulders touching and the heads tilted slightly toward each other.

For three people, set up two stools as in the previous sitting. This time have the two people face each other as they sit a little bit farther apart. Put the third person between them. You may have to arrange the third person in a rather awkward position to accomplish this. If the third person is a child, it is easy to place the youngster standing in between the parents, or on one of their laps.

Sometimes the child standing between the two people sitting can stand on a riser if needed, to get his head up closer to the others. Keep in mind that you are fitting in pieces to a puzzle, or building a pyramid. Think in terms of triangles, ovals.

"Don't be afraid to use the floor in a more casual sitting."

When photographing four, you need to know all even numbers are rather difficult to arrange as opposed to odd numbers in the group total. In these cases, try not to do any groups of four or more in the bust style. Take them to the long side of your studio, or photograph them on your muslin, if they are in their casual clothing. (Muslin is a term which refers to fabric that we use as a continuous seamless type background, which can be purchased in various widths and lengths.) Don't be afraid to use the floor in a more casual sitting.

When you get some static from the subjects about doing full lengths, come in tight and use a horizontal format. In that case, it is easy to seat two people on tall stools and have two people, one in the middle and one on the end. Remember not to have two heads in the same line vertically or horizontally.

For the larger groups of five or more, start with two main chairs with arms on them, and go from there as you begin create a shape for that group. By now you should have learned how to use any chair with arms and how you can build on that foundation.

Casual Posing

The casual posing of any family becomes an exercise in placing them on the floor as you create an arrangement. Since I was trained in era of formal group portraits, I had to learn how to pose people casually later on in my career. I suggest you do what I did, and still do, check out all of the magazines. They are full of casual posing ideas. You should also look at your video ads, and commercials. You need to stay current and be able to give people what they want.

5.12: Here's a casual family portrait using the muslin floor length backdrop.

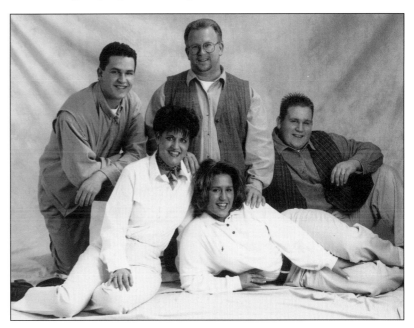

CHAPTER SIX

Children's Photography

If you are going to photograph children, you will learn how to bark like Pluto, squeak like Minnie, squawk like Big Bird, sing like Barney and do a host of rather ridiculous endeavors to get those kids to smile. How you get kids to laugh depends on your personality. We are all on stage from the minute that child walks into our camera room or anyone else, for that matter. Women tend to be better children's photographers than men. I feel that most children relate better to a woman, therefore, I find having a woman assistant very helpful on children's sittings.

Camera Room Psychology

Camera room psychology plays an important role no matter who is behind the camera. It is important that you do not keep that child waiting. Do not bother with any paper work at that time. Ease them into the camera room.

You want to focus all of your attention on the child. "Wow, what a lovely outfit." "What's your bear's name?" "Did you bring your smile?" "Let me show you what we have in our camera room just for you." Use your own technique, do whatever works to get that child to trust you and forget all about the fact they are going to be photographed.

Mothers who accompany children can sometimes be problems. Tell mom that the word "smile" is prohibited in your camera room. Nothing irks me more than the mom who shouts at her kid, "smile." Then, as the child displays his teeth ala chimpanzee style, the mother goes ape, and barks out more instructions.

Most of the time moms are a big help, but when they become a liability, they need to be nicely asked to step out for awhile. I have watched relationships between moms and children for over forty years, from babies, to seniors, to weddings, and then back to their children again. Sometimes moms can unknowingly be a hindrance during the sitting. When you sense that, you may tactfully have to ask her if you may be allowed see if you can do better without her.

I have seen a lot of different behavior in my camera room. Some parents try the "lets make a deal approach," for example, "you smile for

> "You want to focus all your attention on the child."

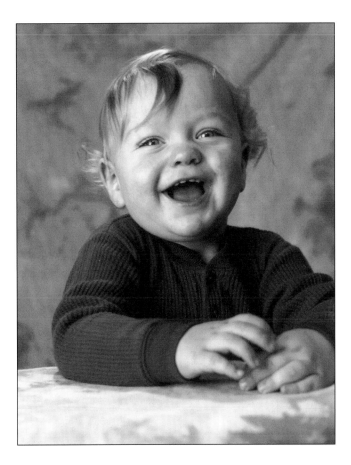

6.1 (upper left): Remember, expressions sell portraits.

6.2 (upper right): Use of the wicker chair lends itself to a beautiful pose.

6.3 (right): Grandma reading to her Granddaughter is always a wonderful pose.

the man and we'll take you to McDonald's." Others do the begging routine, "Please, we have been here for an hour now, please smile for the man." It does not happen often but I have seen some rather harsh treatment on the part of parents in an effort to get the child to behave. My point is that you will be confronted with varying types of behavior as you travel down the path of a children's photographer. Each experience will add to your expertise in ways you can't get from a book.

•When working with children, be quick and efficient.

When photographing children you need to be quick and get your shots before the child has a mood swing. The main point is the expression. I have found the hardest thing to teach is timing, and also recognizing a good expression when it is there.

Knowing when to fire is critical. It comes with experience. The way some small children behave in the studio can be trying, yet very rewarding. When these kids can walk, they will do just that. They will walk all over the place as they meander in and out of your background occasional pausing long enough on the spot just to tease you. Then, as you are fiddling with your focusing knob, they are gone again.

Here is where we separate the very good child photographers from those who are forced to do children's photography and act like they enjoy it.

To be a good children's photographer, you need an act. You are on stage. You have to get this child to do what you want and have them enjoy it too. The idea is to get their mind off what is really going on. The difficult thing is that it takes a different approach for each age group.

Photographing Different Age Groups

Learning what makes the various age groups tick is very important. If you are going to be a good children's photographer, you must study a book or two on child behavior patterns for the various age groups. What works on one age group will not always work on the other.

6.4: "This is my little brother" shot taken on the muslin floor length backdrop.

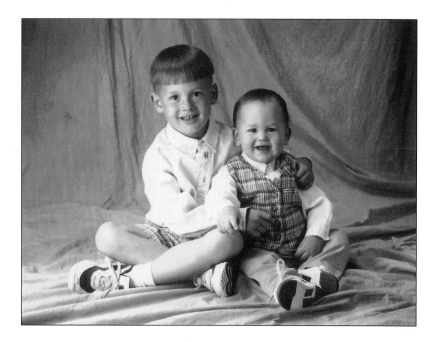

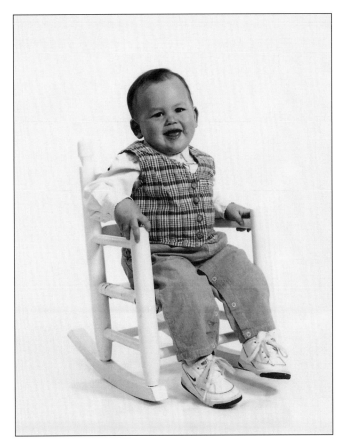

6.5 (upper left): An example of a high key portrait using a rocker as an effective prop.

6.6 (upper right): Children's hand poses are still popular and in demand.

During the non-walking stage, put the baby on a table. Ask the father to sit on a stool right next to the baby to be the catcher. I feel the man is usually better in that role as the mom is better at helping with the expressions. This may not always be the scenario, since dad is not always there.

It is important to have your table set up, all your lights in place, and the background ready. You have only a few minutes graciously given to you by most babies to get those poses which will be admired by generations to come.

The Hasselblad ELX camera, or the current version, the 553 ELX is the perfect camera for photographing children. This set up allows you the freedom to go wherever you need to go to get good expressions. You can easily stay very close to the subject and serve as another safety factor should the baby want to try out for Olympic tumbling. Of course the primary reason for using this system is to be able fire away and never have go back to the camera to cock the shutter and advance the film. It is all done electronically.

For babies, the ideal set up is a low platform or table. Using a low platform means a little more work for you, in the sense you have to bend down a lot, but it affords all concerned a better safety factor. The baby has a shorter distance to fall. It also helps the fear factor that comes from using the usual higher table. You can also photograph babies on the floor, but make sure you use Muslin or some fabric to give you a continuous flow from floor to background.

6.7: With the muslin backdrop, you can offer a lot of posing possibilities.

The lighting that you use is no different than your normal lighting, however you may want to employ an even safer ratio than on your other portraits. In other words, use a little more fill on babies. You can go with an umbrella as a main light and another umbrella as a fill, but If you take this route put both umbrellas on the same side. A soft box works even better as a main light and for an even sharper lighting, you may use a parabolic with a sixteen inch reflector.

Once you have decided how you are going to light, have all of your lights in place, the camera ready to fire, and your gadgets, dolls, birds, dogs, squeakers and your ducks all in a row, you are on. What are you gonna be? A clown? A magician? A stand up comic? A singer?

One thing you can do is play a Disney video tape or CD. How about singing along with the tape or better still, get a Karaoke type tape and be the star, or allow the child to sing along. Even better, let mom get involved. Let's face it: please the mom and you will keep that customer.

The twelve month old is really not a problem. They have just started standing and can't quite go anywhere yet, making them easy subjects for even the clumsiest of photographers. You can usually prop them up on

"...please the mom and you will keep that customer."

6.8: Don't underestimate the popularity of good bust portraits of children. And remember, expressions sell.

a stool or chair and blast away. The eighteen month old child will afford you some opportunities to get creative with your posing and lighting.

The "Triumphant Two-bees" can be a royal pain. These little people have new wheels now, and they know how to use them. They are very quick and extremely cunning. Plus, they are just itching to use a new word they have added to their growing vocabulary. "Would you like to sit on this nice chair?" you ask. Using the new word, they shout back, "No!" Play catch with them; then as they get comfortable with the routine, fake a throw hoping of course they will laugh, and become more amiable.

Most three to five year olds are less troublesome and you might even say more fun to work with. Another gimmick that works for me on older children who are apprehensive is to ask them if they can help me. "Sarah, would you help me? I can't seem to open this roll of film and I need it to photograph you. Here, I got it started, now see if you could get it open so we can see the film."

Most children like to help, especially when they can help the photographer. The whole idea is to let that child know you really are a nice

person, plus you are getting their mind off of the pressure associated with smiling for the camera.

One last tactic I will offer you now is my "you can fire my lights" routine. This works especially on children during a family shoot. Take the radio device off of the camera and offer it to the child, then ask the child to help you test your lights. Now tell them to aim it at a particular light and press the red button. They are extremely pleased when that light flashes. After awhile, you get more kids involved as they test all of your lights, one at a time and one kid at a time. Before you know it, it is a shooting gallery with lights and kid's smiles flashing all over the place. The rest of the shoot is a snap.

Props

You need lot's of props. Here's a short list of props to give your some ideas of what to have nearby when photographing children:

- Rocking chairs

- Chairs

- Stools

- Rockers

- Blocks

- Cylinders

- Fences

- Dolls

- Puppets and toys

- Stuffed animals

- Any set you create will serve to add to your photographs

Where to store all these goodies becomes somewhat of a problem. What can you do? You go up! You can hang things from every available ceiling or wall you can find.

All you really need to be a successful children's photographer, other than your fundamentals, is a love and understanding of children. If you have that, they will know it and so will their moms. Those who lack this feeling will not have to worry about getting too many children to photograph, especially the high end customers.

CHAPTER SEVEN

Senior Portraits

There are many reasons for doing senior portraits. Seniors all have to get photographed to appear in the yearbook. You are building a good customer base. These seniors will become engaged, get married, and have children. If you did a decent job on their senior picture, they will at least start with you when they are planning to get married.

Think of it — every year you are getting a new crop, and they go forth and multiply, at the average rate of two children per family. Like the branches of a tree, these seniors will become your growing customer base. And as you provide them with memories, they will return to you as lifetime customers. If you are convinced seniors are what you want to do, let's find out what needs to be done.

Contract vs Non-Contract

Before we continue, we must decide which avenue to go down relative to the contract vs the non-contract photographer. I have been on both sides of the fence and so what I tell you now comes from my experiences with both sides.

Going after the Contract

In most cases, you are required to contribute a given amount to the yearbook fund. This amount can be can be arrived at various ways: it can be a percentage of all your sales, or a per head price, or a flat guaranteed fee.

In addition, you must supply the school with all film and darkroom supplies needed for them to take and print their own yearbook pictures. You must also cover any event lined up by the yearbook adviser, process and print all film exposed by student photographers, and have a mini-workshop for yearbook photographers. Finally, you must furnish the school with one glossy of each senior.

In return, the school will furnish you with a list of all seniors, agrees to inform all seniors that in order to appear in the yearbook they must be photographed by you. However, "you are under no obligation to purchase photographs." The school will also notify juniors before school

"You are building a good customer base."

is out that they will be getting their appointment in early summer from you, as the official yearbook studio.

Each school you contract with is a different situation. What you give up to get the contract is strictly up to you. How bad do you want it? How big is the class? How many years is the contract? What economic levels do these kids come from? If you choose the contract avenue, here's some idea of what you will need to do.

You need to get an appointment with the principal. Show him or her good samples, good prices, and make the principal aware of all the reasons why he or she should choose your studio. You must above all be honest with yourself! If you got the contract, could you handle the volume?

Many times principals will set up a committee to decide who gets the contract. On that committee, you may have a principal, the yearbook adviser, some parents, and some students from each class affected by the contract.

Principals want to know the financial figures relative to what the school will get.

Advisers want to know about their glossies for the yearbook, activity pictures, how many events you will cover and how fast will you get them to the school. He or she will want to know how much film and supplies they will be allotted.

Parents want to know the cost of packages, sitting fees, deposits, retakes, and refunds.

Students want to know about backgrounds, poses and special effects, and how many changes of clothing are allotted in the various sittings.

Here are some helpful hints on what tell the various members of this committee. When you confront a principal, stress that you are local, which will take all of the complaint heat off him, parents will have a local studio to visit and take care of any problems, and that you are ready and willing to compete on the national studios' terms.

To an adviser, stress fast delivery on all activity pictures taken by you or the yearbook staff and if the adviser is handling the business, tell her about the financial help you will provide.

To a parent, talk about prices, extras, give-aways, retouching, bonuses, re- sitting policy. Parents will tend to be price-conscious.

Tell the students about what interests them most, your poses, backgrounds and your special effects, all about your props, and the fact they can bring in their own props.

The Non-Contractor

Non-contractors can do quite well because they:

- Can charge more per package

- Can get a better sitting fee price

- Can take longer with each sitting

- Are working with people who chose them voluntarily

• Make sure you are well prepared for your presentation at the school.

Left: A high key background with the spotlight and cookie creating the special effect.

Below: In this high key photo, window inserts, which are hung on a rack, are used. A spotlight is also used to create the circle of light in the background.

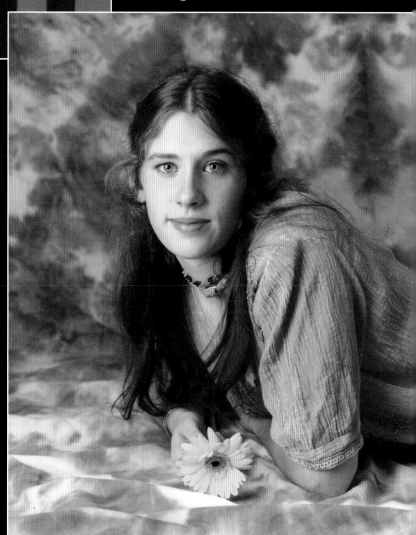

Left: A three quarter length pose with the flag used as a fabric background. By using velcro, you can hang virtually any fabric to use as a background.

Below: A casual pose using the floor and a colorful fabric background.

Above: The muslin backdrops offer many posing possibilities, especially for casual senior por-traits. Notice a gel has been used over the background light to compliment the subject's clothing.

Below: We encourage seniors to bring in their own props to help capture the personality of the subject. Even big props, like this motorcycle, can be used. This shot was also taken on a muslin backdrop and a gel used over the background light.

Left: A three quarter face view with a fabric background and gel on the background light.

Below: This is an example of the "huggy" pose used for a prom picture.

- Do not have to give the school anything — no % of the sales, no film, processing, or pictures

- Escape the cost of sending photographers to cover scheduled events

- Do not have to provide glossies of seniors

- Has a much better per sale average

- A much lower outlay of expenses relative to securing the business

"Most non-contractors do very well..."

Most non-contractors do very well and they're proud of the fact they don't pay one nickel to the school. Result: lower volume, higher averages.

How to Seek the Non-Contract Work

First, you should get a list of the seniors from the area you wish to go after. A national list is not 100% accurate but nevertheless effective. A good source is the American Student List located in Great Neck, New York. Get the names by Zip Code. Get more than 1 set of mailing labels (at least 3 sets.) It's cheaper to order now all at the same time as opposed to later. Don't try to copy their list to save money, because they have trick names used to find out if you are cheating.

You can get a more personal list from a student from your target school. Find a student who is willing to copy the names of the classmates from the phone book. Pay .20 cents a name, (or whatever the rate may be in your area) and addresses. Some photographers get phone numbers too for telemarketing. Remember it is illegal to have the student obtain the list from the school. This must be stressed. We want them to do it the legal way! Student lists are usually accurate.

The use of ambassadors is a good idea. Early in April, get a few girls — pom poms, cheerleaders — and invite them in for a complimentary sitting. The whole idea is to get them to show your work to all their classmates. Give them discounts, complimentary pictures a credit of $5 for each person they send in, you can have a pizza party, beach party or whatever for all the reps. The ambassador system can work very well for you and it can grow as each student begins to tell others about it. Eventually, you will have former ambassadors referring future ambassadors to you.

On the basis of your list, you can send out brochures. These can be letters, brochures, coupons, samples, mail heavy and at least 3 times. Make your own brochures. Most labs have ready made brochures, with pictures already on them. A letter can be full of info about your studio, prices, specials, an early bird special, coupons offering so much off, reasons why they should come to you, etc.

If you really want to play hard ball, you might offer to credit them with the amount of the sitting fee they paid the other studio. Be creative, and be innovative. Keep in mind your goal is to reach enough seniors and convince them that your place is "The place" to go for senior portraits. You've got to understand that you're playing a numbers game and

Shade holder

Bust Area

Negative Room

Work bench

Pyle Corner

Graffiti Area

Muslin Area

Full Length Side
High Key Area

Prop Area or another Background

The first stop is the Bust Area. Then we got to the Pyle Corner. After that, we move along to the Graffiti set up. We follow this by going into our Muslin Area. Now we are ready for the full length side of our studio. Here we do all of our high key photography with our special effects. In this area, we also take full advantage of the spotlight, and most of our props.

so are your competitors. In my own town, all of these items are being utilized and I do feel the effect. So I do know they work. One of the schools, under contract with my studio, had another photographer put in a stuffer, (his brochure) in each of their school newspapers.

Try to get local restaurants to display a few 16x20's of local seniors. How about a McDonald's or a Dairy Queen, or some other hang out for high school seniors? Hook up with a local cinema and get a display of your work put up in their lobby. Think of the exposure you will get.

The local mall is a super but very tough place to be allowed to display. Imagine the numbers you"re dealing with, in one day more people see your work than in one year in your studio.

Don't be discouraged in the beginning of your display campaign if nothing much develops. Keep it up. It's seed planting for future cultivation. It has always worked for me and it will work for you.

Photographing Seniors

Now that the mom has been seated and the senior has entered the camera room, we are ready to begin. The following describes how we photograph approximately 1200 to 1500 seniors from June to October. The only way this can be done with only one photographer in a rather small room is to organize the route which every senior will take.

The room has to be set the room up so there will be a minimal amount of moving lights, cameras, and props. This means that as we go into each nook and cranny of my camera room, a background awaits with the necessary lighting in place. It is an assembly line set up, but it must not look as if you are working in an assembly line atmosphere.

As I describe each of our shooting areas, I will include sketches or photographs of what the area looks like. This section will be organized around an imaginary tour of our studio as one would set up to photograph seniors.

7.1: Here's the bust type portrait area showing the background holder, the fabrics and the posing table.

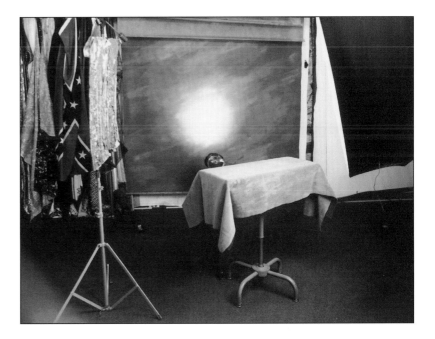

The Senior Bust Type Area

The first stop is the area for senior bust type photographs. Here, we use a tripod on which we have the RB camera with a 180 mm lens. You can also photograph many other types of poses in this area. This is possible because there are four pull down canvas shades to use as well as the wall directly behind the subject. The shades are hung on the wall with the use of a home made holder. In addition to these options, there are a few more backgrounds on that wall just behind those shades. Here are some other background ideas you can use.

Foamcore board — with various kinds of foils crinkled on them and some fabric also. We get our four by eight foot sheets of boards from Fomebords of Chicago. They can be cut into pieces of about five feet by five feet and hung on the nail with the use of with my trusty picture hanging wire. That same wall with nothing on it is also a background option.

To make a Foamcore board bust type background, order a roll gold foil paper or gold metallic Mylar from a prop company. We use Studio Specialties in Chicago. These foils, papers, and vinyls come in rolls of various widths, from forty two inches to sixty inches. Spray adhesive on one side of the cut to size foamcore board. Now take the gold Mylar and scrunch it up as you begin to fasten it to the already tacky foamcore board. Or you may use a staple gun as I do, to put those folds and crinkles exactly where you want them. Depending on what size boards you use, you may choose to work in very tight on these poses. This allows

7.2 (left) and 7.3 (right): Two examples of typical hand poses used for the bust type portrait.

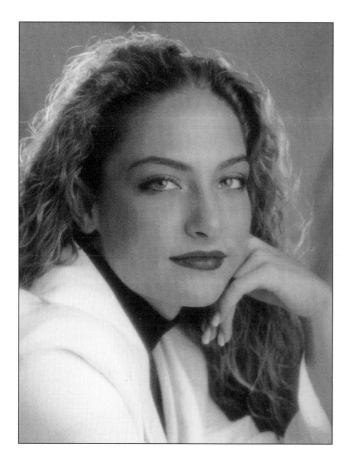

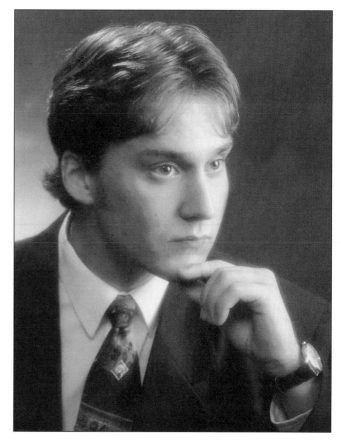

you to use a smaller board, which saves a little wear and tear on the photographer. By using a backlight with a gel on your background, you will create a very interesting pattern, as the light bounces in an out of those scrunches you designed.

Fabrics — now add fabrics, which are on the wall to the left of the above mentioned backgrounds and you have even more options. The senior starts here with the yearbook pose, and can stay in this area if you feel the senior is wearing the appropriate attire for some of these additional shots.

There are approximately thirty different fabrics on the rack to choose from as you search for what would be an appropriate background for that subject. Believe it or not, you can use these fabrics as backgrounds on boys as well as girls. You can find almost any pattern you want at any fabrics store or department store.

To hand the fabric, put a piece of Velcro on each end of the cloth, and a piece of Velcro all along the wooden strip on the bottom of one of your canvas shades. As needed, you affix the fabric to the Velcro on the shade, creating yet another background. These fabrics are hung on the wall, which is adorned with two strips of Velcro, as they await your need.

A Mini Blinds background — is just above that bust area directly behind the subject. This background is on a pulley and raised up out of the way until we need it to become a background. These mini blinds are reversible, white on one side, black on the other.

By using the black side of the mini blind black side and a dark background and placing red gel over your background light, you can come up with some stunning effects. You may also use the white side of the blinds, giving you even more options.

The Pyle Corner

Now for the rest of the sitting, we will use a camera stand which has an RB camera with a 127 mm lens on it.

The Pyle Corner is just right of the senior bust type area. This area has a background which resembles those swinging racks they have in lumber display stores which are used to display their various four by eight panels.

It gives you another four backgrounds merely by swinging the panels in and out of the way. They are angled in such a way that they are flush against the wall all of the time.

What you decide to put on those panels is, of course, up to you. You can use a brick pattern, a stuccoed pattern, and a black vinyl homemade affect on another.

The Ebony Area

This area has a black vinyl background made by using a roll of black vinyl, cut to about eight feet, then placed on the panel in a fanned out, pleated effect. To make it, start in the middle of the piece, begin stapling your pleats fanning up and out and down and out, pulling while you are stapling. This background is used for girls. The subject stands in front of it, arms folded, her back almost touching the background. We come in

•Hang the fabric on canvas shades using Velcro.

7.4: Camera stand with tray.

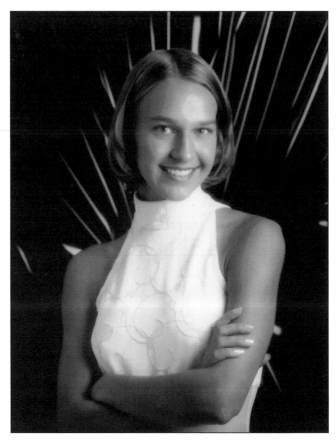

7.5 (upper left): "The Ebony" background in the Pyle area.

7.6 (upper right): Here's an example of a senior pose using the Ebony setting.

7.7 (left): The mini blinds background (see photo 7.10).

7.8 (upper left): A foamcore board cut out hanging on the rack, with a spotlight (using a cookie) effect on the high key background.

7.9 (upper right): Here's an example of a senior portrait using the foamcore board and spotlight.

7.10 (right): An example of senior portrait using the mini blinds background (see photo 7.7).

7.11 (upper left): The brick panel in the pyle area.

7.12 (upper right): An example of a senior portrait using the brick panel as a background.

7.13 (left): This senior is posed on a full length muslin backdrop using the pillar as a prop.

7.14 (upper left): Window inserts hung on the rack.

7.15 (upper right): An example of the window inserts used in the background of a senior portrait. A spotlight effect was also used.

to just below the waist for this shot. It is a very good seller. For those of you who wish to be frugal, you may use a dark garbage bag.

The Graffiti Area

To the right in our studio, we move into the Graffiti area. This area is made with two sheets of Foamcore board set in a v shape. This foamcore board is painted to look concrete block. You will have to repaint this every year right over the 1000 names or so.

As the students approaches that wall, ask them to sign in. Hand them a felt marker and they proceed to put their name on the graffiti wall. Then you photograph them.

The Muslin Area

Next to the graffiti area, this part of the studio features two long muslin backgrounds. They are hung from the ceiling by a wooden dowel which holds the rings attached to the muslin. One muslin is painters cloth ivory and the other is blue. What the senior is wearing governs your decision as to which muslin will be used. In this setting, you can do full lengths, sitting down poses, and reclining type poses. These muslins are easy to pull in and out of the way, since everything that is done has to be quick and easy and still look well done. We love it when the students or even the mom says they can't believe how we can create so many beautiful backgrounds in such a relatively small room. And, I might add, in a relatively short period of time.

7.16: *The muslin area, showing the
full length muslin backdrop.*

7.17: *An example of a full length senior
portrait in the muslin area.*

It should be mentioned, while we are doing all this photography, we are working with one student in the camera room, plus one student in each of the three dressing rooms. There must be a constant supply of seniors, so that while one is changing we are already working on the next senior. Before we leave the muslin area, it should be noted this is where we do a lot of the seniors who bring their own props with them. We do encourage everyone to bring their own props, basketballs, baseballs, bats, soccer balls, cycles, rifles, guitars, drums, pets, stuffed animals, whatever. You bring it, we shoot it. In this muslin area, we do some of our most creative work.

Full Lengths

Now we make another right turn and we find ourselves in our full lengths shooting area, which is located opposite the short shooting side of our camera room. In this area, we do our high key full-length portraits. The background for any of the full length shots always includes a pattern created by the use of our spotlight with various cookies inserted. This light is used on every full length picture. Patterns in your background, created by the spotlight and cookie, will certainly spice up your high key photographs. Cookies can be purchased from the makers of the spotlights or you can cut them out yourself.

Props

The full length area is also where we use a number of props. Here are some ideas for props and how to use them:

- *The Year Prop is a one* of a kind wooden prop was made especially for us by a carpenter I befriended some years ago. This prop is a heavy piece of furniture carved out of wood showing the actual current year. It is made so the student can sit on it. The girls are posed sitting on it with their feet on the side of the number so as not to cover up the year. The boys are posed sitting on a stool, then placing one foot on the prop and the other foot placed on the first rung of the stool. Naturally, there are other ways to use this prop. At the end of the year, we raffle the year prop off to a senior.

- *The School Block* is a one foot block, the front of which has a piece of Velcro on it to which we affix a plaque with the schools letters and colors on it. The senior sits on the floor and uses this prop to put his or her elbow on it.

- *The Pillar* is just what the name implies. Go to a place that makes forms for cement columns which are used in highway building. They come in various diameters which allows you to choose the column size you need. They will cut it for you in the length you desire. After you wrap it with some vinyl, or even paper, you have a very nice looking pillar.

"The full length area is also where we use a number of props."

- **The Rack** is a 2x2x8 piece of wood with hooks on it used to hold the foam boards or the window inserts. The rack, which is suspended on a pulley just above the full length area, serves as a clever way to display more options. When you lower the rack you can hang Foamcore board on it creating yet another background. These pieces of Foamcore have various cut outs, and openings, already cut by us, which allows the background area to be seen through the cut out. When the rack is not in use, it is pulled up to the ceiling and totally out of the way.

- **The Window** can be hung on the rack which creates still another scene. These are window inserts, which you can buy at any lumber yard. They are those inserts that fit on the inside of windows giving them that french door look. By using a gelled background light, you can create some rather original stuff.

Other props used in that area include blocks, cylinders, stools, chairs, director chairs, small step ladder, room dividers, on which we hang any jackets, medals, or other attire that the senior wishes to display in his or her photograph.

The End of the Sitting

When the last shots have been taken on this full length side of our studio, it usually means the end of that person's sitting, and the beginning of the next person's sitting. This is how it goes all day long. Although you may feel that all of the decisions have been made, you still are confronted with which backgrounds, which props and which gels to use plus a few other decisions to make at every stop. This is where you unleash your creativity.

CHAPTER EIGHT

Proms for Profit

In this chapter, we will discuss why you should do proms, how to get them and how to photograph them.

Choosing to Photograph Proms

Here are just a few reasons why you should consider photographing proms and other dances.

"...one of the few times you will ever get cash up front from a senior."

1. This is one of the few times you will ever get cash up front from a senior.

2. By the time they get home that night, you will already have that money in the bank! How much money you will have depends on your package prices and the number of couples that attend (almost every couple buys).

3. Are proms profitable? You could actually make more money on a decent prom working three hours than on a wedding working all day. And you don't need special equipment. You already own what you will need since your wedding equipment will do nicely. If you can shoot a wedding, you can do a prom. It's like photographing many brides and grooms. Pose, focus, and shoot.

4. At most schools, they have four, or sometimes five couples dances each year, which is another reason to think about doing dances. I suggest that you consider not booking weddings on the dates in May on which you have a prom.

How to Go after a Prom

If you opt to go after a prom or two, here is a game plan on a month to month basis.

The Schedule

Starting with January, send a letter to the school with samples letting them know you're interested in doing their dance, and that you will be

calling them very soon to make an appointment. This way, when you make the call, it won't be a cold call. You can also go in person and get to see the sponsor.

In February, the whole idea is to be assertive enough to get an appointment to make a presentation to the committee. When seeking prom business, you need to use direct mail, telemarketing, and personal visits. Be a pest. Then in March comes the presentation.

The Presentation

No matter how you make your presentation, live, audio visual, video, or whatever, here's what my 39 years experience tells me about students. What they really want to know, all they're concerned with, and what you should base your talk on are three things. Number one is backgrounds. Number two is backgrounds, and number three is backgrounds.

Tell them what they want to hear. "Our set designers will create a beautiful background based on your dance theme." "Of course, if you would like something you've seen in our sample book that's available too." The important thing here is to get them talking about possible backgrounds, how you will work with them to make their prom unique, possibly even subtly chipping in with some ideas of your own.

• The students' main concern will be the background(s).

At this point, always make sure they know that you have two types of backgrounds, well three actually: the painted scene, a set with props, and a combination of both.

Tell them that if they choose the prop type background, they can interchange all of the props they see and actually be in charge of what the final set will be. If you want to work a bit harder, tell them you will build the set in advance and show to them before the actual dance. Sponsors like this as it gives them more security and control. The trick here is to allow the committee to think they are in charge; however, you must always be in control.

Now a word of caution! Do not let them do their own background for you. Yes, it is tempting. No cost to you. No work for you. But it really is not a good idea. Keep in mind your name and reputation is behind every one of those pictures. It is not in your best interest when there is a tree branch protruding from some boy's hip, or a leaf growing out of a girl's hair. Do your own scenes, or have a pro do them, after you've given them a sketch. You can consider buying some ready-mades from suppliers in our industry. Another good source is the trade shows. Later on we will discuss how we have them done.

While planning your presentation here are some points that will be brought up. Sponsors will want to know the price of packages, how long on delivery time, how will they be delivered, who does the collecting, will the students spend all night in line, who sets up and takes down the background, and what is your refund policy. When talking to the students, mention backgrounds and creativity. And how you will work with them, and they will have some input.

You must state your pricing schedule clearly. We offer six options that night and each option offers a chance to double up.(Order two sets). Later on in this chapter, I'll tell you how we sell that night.

8.1 (upper left): A standard boy pose.

8.2 (upper right): A standard couple pose.

8.3 (right): A standard girl pose.

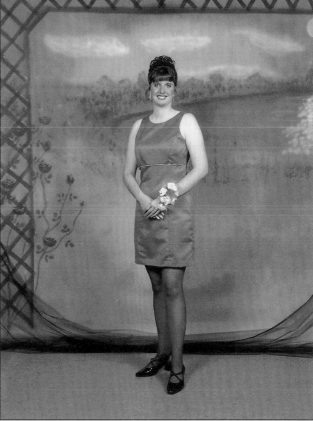

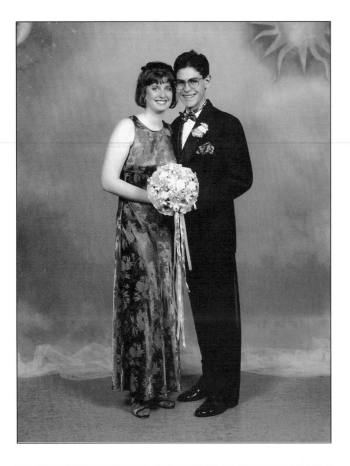

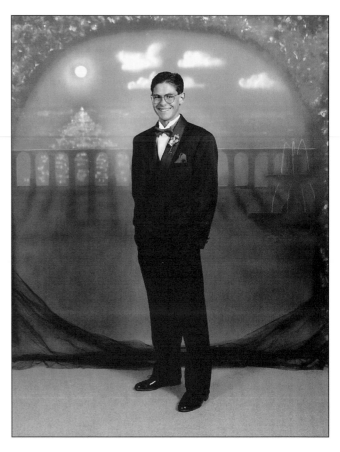

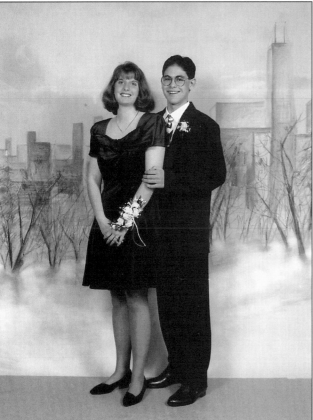

8.4 (upper left): Another standard prom pose.

8.5 (upper right): Try to convince the students to let you do the backgrounds — or you may have a less than professional-looking background to contend with.

8.6 (left): The set up is important — be sure to get there early so everything is ready when the first couple comes for their picture.

"...talk about how you will handle the scheduling..."

We are forbidden both by federal law and, of course, by the ever watchful Professional Photographers of America (PP of A) to give prices up front, during the presentation. Also during the presentation, let them know you should have the pictures ready in two weeks unless school is out sooner than that. Tell them they will be delivered to school in alphabetical order each in its own bag.

During the presentation you should also talk about how you will handle the scheduling of students for their photographs. If you can avoid it, you do not want a scheduling system based on an appointments. It will slow you down. You must have a constant supply of couples. Most schedules confuse people and very few students really pay attention, they just hop in line as they see fit. When we used to offer only one pose packs, I would do 95 an hour. Now that we are doing up to five pose selections, we can crank out around 50 per hour.

If the school insists on scheduling, here is my favorite system. As each couple gets to the dance they are handed a card which has a fifteen minute time segment on it. Twenty couples are scheduled at 8 to 8:15. The next twenty get 8:15 to 8:30 and so on. This way, each couple can enjoy the dance until their fifteen minute time slot is up. Theoretically, a student will be in line no longer than fifteen minutes.

There are a lot of ways to go about the scheduling of appointments and many have been tried. Frankly, there is no way to avoid the line, and most kids accept it. One thing is important: you should never adhere rigidly to appointment times, just shoot away. I am certainly not interested in telling the all state linebacker to step to the back of the line because this not his appointment time. In the old days of one pose packs, one photographer would do 300 with one crew. Of course, now with the multiple pose packs, you need two crews if the total is over 150. Some of our packs include the couple, the girl alone, the guy alone, and the "huggy" pose. (The "huggy" pose is a three quarter length shot of the couple holding each other close.) There are other systems. You just have to learn to pose fast and fire quick.

At the presentation, also mention your refund policy. Refunds are very seldom necessary. You must learn to see blinks. Our refund policy, if needed, is a simple one. If it was a one pose plan, I personally write them a letter and offer two options: money back or a studio sitting. It never fails to impress them, if they can come to the studio and get a portrait sitting. If it was a multiple pose plan, we add another option; they can choose from any of the other poses to make up for the blinked shot. I usually do whatever is needed to satisfy that couple. These are our students and we take good care of them.

Photographing Proms

The equipment you'll need includes any 2¼ medium format camera will do nicely. Also, a long roll camera is ideal. You will also need to use a tripod.

As to the lighting, we use two umbrellas powered by a 400 watt second power supply. One light is seven and a half feet from the subject(s) and the other is about eight and a half feet from subject(s). You

do not want any shadows on the background, so this lighting is simple and rather flat but extremely safe. This type of lighting can save you if one of your lights unknowingly was not firing. In this situation, the other umbrella light will still give you a saleable print.

Always use your meter to make sure the lights are positioned where they should be so you have an f stop reading of at least $f8$.

As I emphasized earlier, backgrounds are crucial. By using two stands with a pipe shoved through a nine foot roll of seamless paper you have the painted scene background holder. There are regular background holders made especially for seamless paper, which can bought at any large photographic supply store.

If a prop type set is used, you can use the same set-up utilizing a roll of seamless paper as a background and then build a set around that. You can mottle the paper with spray paint and/or pastels.

One way to get backgrounds is to latch on a local starving artist and work with him or her on how to do one for you. Pastels will work fine and airbrush work is even better. You can use these backgrounds more than once, at other schools if the areas do not overlap.

A carpet is used as the floor, which must be at least nine feet by five feet to adequately cover the photo area. Go to a carpet place and by some remnants. Lately, we have used paneling, covered with vinyl, muslin, wallboard, and linoleum as flooring. Harder to lug around, but nice to work with.

The Night Before the Prom

Be sure to make a checklist, and check your equipment the night before. Be sure to pack up backup equipment, this is very important!

The equipment should include two stands or portable background stands for the seamless paper and the crossbar that goes through it to hold it up. Two umbrellas, two stands, two flash heads, and a power pack, with plenty of power cords, shutter cords, extension cords etc. along with a good supply of duct tape. And, of course, your tripod, camera, shutter cord, and film. Be sure to have your carpet or other floor covering ready to go as well.

Remember you will need change (singles and fives), a stapler, a receipt book, envelopes, *et cetera*. Use a brief case to carry these supplies.

Setting Up on the Day of the Prom

Set up the morning of the prom. If there is going to be a problem it is best you know it way before the time the couples arrive. Start by setting up the background by hoisting the paper up to about nine feet and letting it roll down to the floor just enough so that you can have about four feet of paper underneath your flooring.

Before you put down the carpet, or whatever you will be using, you must tape the paper to the actual floor. Now you can lay the carpet down and tape it, at least where the traffic will be heaviest.

Tape the carpet, the background holder stands, the light stands, the cords, and clamp the top of the background paper. Use gaffer tape, which is sold to commercial photographers and stage lighting people. Although normal duct tape works well, extra strength is better.

"...check your equipment the night before."

8.7 (upper left): Here's another background idea including a "window" with a vase and pillar as props.

8.8 (upper right): Each member of the prom crew has a specific function. A well organized team will be an asset to you on prom night.

8.9 (right): Make sure to write down the dress description on each receipt — this can help you if the packages get out of order.

The lights, which are two umbrellas, are placed as follows: the main is about four feet to the right of the camera, and is seven and one half feet from the subject. The fill is close to the camera on the left side and is eight feet from the subject. The main is about seven feet high and the fill is a bit lower. I get an f stop reading of $f8$ to $f11$ from my lights, which are powered by a 400 power pack. Set the camera on $f9.6$. All of the cords are taped to the floor as are the light stands. After everything is set up and taped, test your lights and camera.

Next, set up the receipt tables so that when the crew walks in at night, all they have to do is fire up. When setting up the sales table, put it where it is best for the traffic flow. Leave as much room as you reasonably can between the sales table and the shooting area. The waiting line should be behind the background.

The line should never be in a position to be able to see the couple being photographed or be seen by the couple. The next couple up or as I say, the couple in the on-deck circle, will be able to view the couple, but only from the side. Never have anyone behind the photographer.

The ideal set up is when the receipt table is placed somewhere behind the background. The line forms to get to the receipt table. Then ideally there should be another small line waiting to get to our poser. All this time, no one can see the background and most important the couple being photographed can not see anyone and is not being watched by anyone, other than the photographer and the poser.

You can gain speed by having the line waiting to be photographed come up right to the edge of the background. The last step is to have them exit the other way as the next couple is being ushered in.

Prom Night

You should have a crew of four and possibly five is in place: two writers, one poser, one photographer, and a logger loader if needed.

Receipts writers collect money, write receipts, and write a gown description on each receipt. They give one copy to the couple, and keep the other in the book. As one writer is writing down the choice and the gown description, the other is collecting and making change.

In addition to this, it is their responsibility to put down some sort of identification of the couple to help us in the studio during the packaging. They hand one part of the receipt to the couple and tell them to give it to the poser when it is their turn to be photographed.

The poser is the most important member of the team. He or she takes the receipt, calls out the pack number to the photographer, puts the receipt down in sequence, then poses the couple.

Speed is crucial; fast and efficient are the key words. However not too fast to where the couple thinks they are being rushed, but quick enough to get everyone photographed before the dance is over. Posers must first be writers and then go through a few training sessions before we take them out on the real thing. Posers are also trained to spot blinks, and to watch for a light that may not be firing.

The photographer composes, focuses, refines the pose if needed, fires, looks for blinks, advances, and keeps up the log. You may also have another person take care of the log. The logger keeps a log of

•You'll need a crew of at least four to help you prom night.

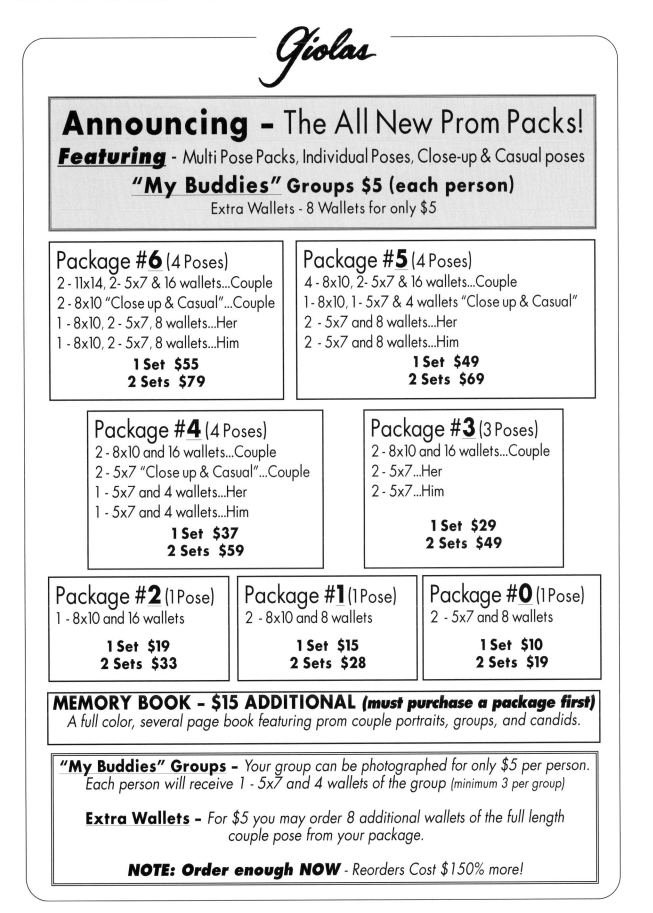

Giolas

Announcing – The All New Prom Packs!
Featuring - Multi Pose Packs, Individual Poses, Close-up & Casual poses
"My Buddies" Groups $5 (each person)
Extra Wallets - 8 Wallets for only $5

Package #6 (4 Poses)
2 - 11x14, 2- 5x7 & 16 wallets...Couple
2 - 8x10 "Close up & Casual"...Couple
1 - 8x10, 2 - 5x7, 8 wallets...Her
1 - 8x10, 2 - 5x7, 8 wallets...Him
1 Set $55
2 Sets $79

Package #5 (4 Poses)
4 - 8x10, 2- 5x7 & 16 wallets...Couple
1 - 8x10, 1 - 5x7 & 4 wallets "Close up & Casual"
2 - 5x7 and 8 wallets...Her
2 - 5x7 and 8 wallets...Him
1 Set $49
2 Sets $69

Package #4 (4 Poses)
2 - 8x10 and 16 wallets...Couple
2 - 5x7 "Close up & Casual"...Couple
1 - 5x7 and 4 wallets...Her
1 - 5x7 and 4 wallets...Him
1 Set $37
2 Sets $59

Package #3 (3 Poses)
2 - 8x10 and 16 wallets...Couple
2 - 5x7...Her
2 - 5x7...Him
1 Set $29
2 Sets $49

Package #2 (1 Pose)
1 - 8x10 and 16 wallets
1 Set $19
2 Sets $33

Package #1 (1 Pose)
2 - 8x10 and 8 wallets
1 Set $15
2 Sets $28

Package #0 (1 Pose)
2 - 5x7 and 8 wallets
1 Set $10
2 Sets $19

MEMORY BOOK - $15 ADDITIONAL *(must purchase a package first)*
A full color, several page book featuring prom couple portraits, groups, and candids.

"My Buddies" Groups - *Your group can be photographed for only $5 per person. Each person will receive 1 - 5x7 and 4 wallets of the group (minimum 3 per group)*

Extra Wallets - *For $5 you may order 8 additional wallets of the full length couple pose from your package.*

NOTE: Order enough NOW - *Reorders Cost $150% more!*

each frame so the lab will know exactly what to print for us. They also load film for the photographer, and help watch for blinks and any other items the photographer might miss. It is important to spot blinks. It takes experience to actually see the blink. Ask the poser to watch the boy. The photographer watches the girl. When I am on the assignment I can see both. When any of us think we see a blink we shout "blink." No argument! We take it again!

Identifying the Couples

You must have a method to identify these couples and their order. You can use a guide sheet or use the log system as we do (both of these items are supplied by your lab). As each couple walks into the set, they give the poser the receipt. She puts each receipt face down on a pile until the photographer cranks out the last frame.

At that point, those receipts are stapled and put into a bag marked Roll 1 with the roll of film. Mark the roll, the batch of receipts, the bag roll 1, and so on.

Caution! Once that receipt is placed on the pile, that couple must go directly to the photo area. Remember, if one receipt is misplaced, you

8.10: "My buddies" group shots can be taken at the end of the couple's photography and will add to your night's sales.

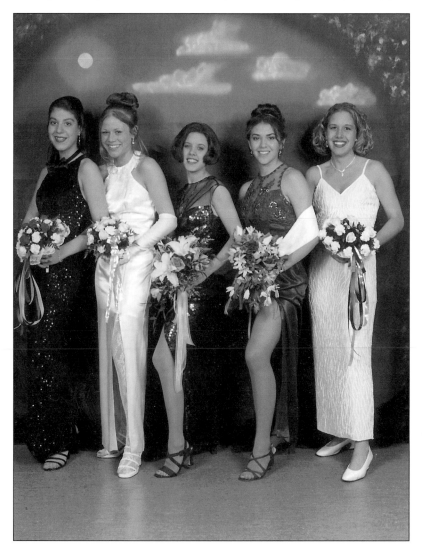

"The gown description
plays an important role
when mistakes crop up."

can get 24 wrong! Not to worry though, the descriptions on each receipt will rescue you.

When the lab sends the work back, they should give you uncut rolls and all the pictures for that roll all in one batch, and in the proper sequence. They must be marked with the twin check on the roll of film, and on the bag with that batch of orders in it. The gown description plays an important roll when mistakes crop up.

Selling the Photo Packages

What can you do while they are choosing their packages? Why not use the Fast Food method. No matter what you order at a fast food chain they will respond with, "You want fries with that?" What happens is that inexpensive trip to a fast food place for a .79 cent hamburger, turns out to be a $3.95 expenditure. So why not try this with the prom packages. No matter what plan the student orders, you can say, "Will that be one set or two?" My sign will have six plans and each plan can be doubled. I call this the fast food ploy. You can actually do 30% more business if you use it. You should also always ask, "Do you want extra wallets with that?" Do not hustle them, just ask. Simple old peer pressure will do the rest.

Another way to make more money that same night is to take "My Buddies" group shots. These pictures are taken once you are all done photographing the couples. Groups are photographed at so much per head, with everyone getting one 5x7 and four wallets. Do not be concerned about shooting off of the background on these gang shots, just set 'em up as quick as possible and blast away. It's popular with the students, and you get some extra revenue for the night.

CHAPTER NINE

Getting Your Studio Known

"The key to survival is to be sales oriented."

In order to be successful in our business today, you must first consider yourself a business person. The key to survival is to be sales oriented. The more you learn about running a business, the better off you will be down the road. I put the emphasis on the more you learn how to bring people in, the more successful you will be. In addition to attending programs on lighting and posing, you must get a hefty portion of learning on how to market your skills.

Study the photographers who know how to market their product, and you will succeed. I have said it before and I will probably say it again, give me an average photographer in the camera room with a keen sense of marketing abilities, and add to that a people-oriented receptionist, and I will show you a successful studio.

Promoting and Marketing Your Studio

The first thing you have to do is begin letting everybody know who you are, what you do and where you are located. You are competing for the discretionary dollar which means you have other competition besides your photographic competitors. The jewelers, the sports stores, the gift shops, the electronics stores, and most other merchants who compete for the same dollars are your competition. You must think of yourself as business person first and then as a photographer. The more effort you put on how to get people to spend their money in your studio, the more successful you will be.

Inexpensive Projects for Starters

There are several ways to get your studio known without spending a lot of money. Always be watchful of your budget, but even more so in the beginning of your business. Therefore, you should place your emphasis in getting known with the least amount of cash outlay.

Civic Organizations

Right from the start you can join a civic organization such as Rotary, Lions, Kiwanis, or church groups. Your library has a complete list of

every club in your town. Every town has more than a few, which means you can be rather selective if you wish. Instantly you now have fifty or so new potential clients. And you are on a first name basis with every one of them. Get involved with community affairs. Volunteer your services for town functions. Put on informative programs for any local civic organization. Once the other civic club program chairpersons find out about your willingness to do this, you are going to be one busy celebrity. And eventually so will your studio. (This is easy to do, it will get you known, and it is free!)

Get your Name in the Newspaper

I call it free ink. I ran in races. "Local photographer runs in marathon." Half the time I didn't even finish. But I got my name in the paper. The whole idea is to get involved and get your name in the paper. Find a way that works for you. You can sponsor events, such as races, a run, or a walk for fun type charity events that will surely get written up.

Displays

There are a lot of bridal shows and county fairs or even home type shows that would welcome your business. For a fee, you are allowed to set up a booth and display your beautiful photographs and meet new people. Libraries allow artists to display their work. Set up a display at your library. When you are through at the library, you can look for other locations that would allow you to display your work, such as banks, malls, _et cetera_. Restaurants are another source well suited to display your work. Display your work!

Direct Mail

Direct mail is a great way to get known. One of the biggest reasons I bought a computer in 1987 was to send out direct mail. And there are so many uses for direct mail which is really a rather inexpensive way to get your message out. The key to direct mail is volume and frequency. Don't expect to get a tremendous response. Remember whether they respond or not, you have reached that person with your name. Keep your name in front of the public any way you can. It will eventually pay off. The idea is to make your name synonymous with the word photography. Who to mail to can include babies, engagements, people in the business news, and naturally your very own customer base. Use that customer base often as you let people now about your specials. Direct mail is a definite must for you. Do it often.

NewsLetter

Another idea is to publish a newsletter. This newsletter can tell your customers what is new at your studio, sales and upcoming special events. Again computers and software can do all of this for you.

The Yellow Pages

You do not need a large ad. Sometimes a new owner wants to make a statement so he buys the biggest ad of all the photographers. In my opinion not a wise investment in the early stages of your career.

A reasonable size well done ad will suffice. Put your savings from a big ad to a smaller one into your direct mail campaign. One more thing about the yellow pages. These days it seems there are more than one yellow pages for a town or community. Make sure you are advertising with the yellow pages that will benefit you most. Be on the lookout for look alike yellow page direct mail ads. Make sure you're dealing with the real thing.

Newspaper Advertising

Advertising in a newspaper can be rather tricky. You must consider newspaper advertising as a means of keeping your name in front of the public. Many times there is more than one newspaper in a town. Often there might be a daily plus a weekly newspaper. It is in your best interest to contact each of the sales people, and write down their rates. In the beginning, the weekly might be a wiser choice. Compare each newspaper's circulation with their rates. Newspapers charge by what they call a column inch.

• When buying ads in the newspaper, check the contract rate.

For instance, if your ad goes across two columns and goes down four inches, you will multiply two times four and get your column inches for that particular ad. Some newspapers have a lower rate if you buy a contract. They call this a contract rate. You are spending less per inch, but you are agreeing to buy X amount of inches that you can use over time. For example, you can buy 120 inches to be used within a 12 month period. If you definitely know you are going to advertise in that paper, it is to your advantage to purchase the contract rate.

Even if you do not have anything to advertise in a given month, you will get a rate holder so you can fulfill your minimal contract agreement. (A rate holder is a small box which will appear every week in which you can put your name or a message or even a picture if you wish.) Do I suggest advertising for you? You better believe it. Even though you don't get the expected response, I will tell you advertising does pay.

Billboard Advertising

This is still another vehicle for publicity. Check it out in your town. Ask if they have a rotary sign program...the sign appears in different locations every month. You may find it is not as expensive as you assumed. When I did it, I was trying to convey a message to my clients which was, "If he can afford a billboard, maybe he is doing well, if he is doing well, maybe he is good; consequently if he is good, then I want to go to him." How can you afford it? Easy, just limit all of your other advertising that year.

Airplane Advertising

Have an airplane with your banner or special offer fly over a football game. If your town has a few high schools, and they are all playing at the same time, have the airplane go over all of them.

Doing business without advertising is like winking at a lovely lady in the dark, you know what you are doing, but nobody else does.

CHAPTER TEN

The Promotional Calendar

This is an effort to put down on paper exactly what it was I did to survive in this business for forty years. Some of the information in this chapter will be taken from a policy manual I made, and a lot of it will be the thoughts of many years as well as I can recall them.

The heart of this chapter will encompass a month by month calendar which you can use to keep you focused throughout the year.

My Philosophy

- Work from a "To Do" list every day. My list goes with me all day long. So does a note pad used to put down any thoughts I have relative to my business throughout the day.

- Do not start your day in neutral. Tell yourself you are going to get something done today, program yourself to win.

- Be a double timer, which means try to do more than one thing at a time whenever feasible. Listening to motivational tapes while driving is an example of double timing.

- Plan while working out. My most productive double timing was when I was training for marathon running. While running or any kind of work out you can plan your week, rehearse a presentation, plan your next meeting, or think about anything that would relate to your studio.

- Even when you are at home, watching television, you should have your notepad with you, in case a thought enters your mind.

- When you learn to delegate duties, and allow others to lighten your load, you will learn to love it.

- Hire good help, and have the "good sense" to let them ease your load. You can't do everything yourself, even if you think your can do it better.

- Realize your strengths. Do what you do best. Delegate the duties you do not enjoy, and the chores in which you are weak, then step aside and let them get done.

- Have weekly meetings. Listen to your staff.

- You must learn to prioritize. Each day when you come in, you need to make quick decisions relative to what is going to be done and who will do it. Realize that on certain days you will have to re-order priorities as "stuff happens" in the course of your day. If you can't get the list done, get the important things done.

- Don't sweat the small stuff. If you get swamped by large projects, cut them up into smaller projects and do them one at a time.

- Don't spend time worrying about decisions. It's O.K. to do some research if you are concerned but, don't get hung up; make the decision and move on.

- Sometimes it's a good idea to switch from a task for a while if you are running out of gas. Tell an employee to take a ten minute break when they feel frazzled. It is better than blowing up in front of a customer or making a critical error on an order.

- After studio hours, I feel it is important to have a life when the studio is closed. To me, this relaxation outside of photography is a necessary part of a healthy business.

- Avoid working on a project obsessively in an effort to make it perfect. A product with zero defects, does not exist.

- Every year in January, when things are slow, it is a good time to reflect.

- Keep a diary, or a daily log (which could be your appointment book). You can enter anything that will help you for this coming year. You can make very good use of this appointment book, by recording everything that is pertinent to events that will be repeated the following year. It serves as another log which will help you schedule events for the next season. Included can be items such as when you started certain schools, how many came in, when you sent the glossies to the lab, *et cetera*. Any information you think you will need to know for next year is put in that appointment book. It does not take a systems analyst to realize most of what will be done this next year has already been detailed in the appointment book, as well as your diary.

"...use your appointment book as a time release file."

With that in mind the first thing you do in January is get both of the appointment books and begin putting down into next years appointment book what will be helpful for this years scheduling. This allows you to use it as a blueprint for the new year. I find an easy formula that works and I stick to it.

In addition, use your appointment book as a time release file. If you need to remind yourself of something that must be done on a certain day, put it in your appointment book on the day or the day before it should be done. This way even your employees will help you remember what ever it is we need to do on that day.

Yearly Calendar

This month by month calendar provides ideas for promotions and details what activities should be done. As with every business venture, timing is crucial and pre-planning a must. You can use this calendar as a blueprint and modify it depending on what portrait services you plan to offer your customers.

January

Sit down with your staff and look at your price list and contemplate possible additions or deletions. Talk about the previous year...consider any changes, praise the employees. Schedule weekly meetings for the whole year. Your employees are the ones who are dealing with your customers one on one. It is in your best interest to listen to them often. Many of the best ideas will come from interested employees. This is your way of checking the pulse of your customers.

In case you don't already know, studios usually do not have any cash flow to speak of in the early months of the year. Your focus in the these months is to get some bucks into the studio. Go after the business.

Have a cash flow sale. You just tell people, "We need some cash flow. Take advantage of us now."

Run a "senior wallet special." Tell your seniors about it in a mailer. This letter should include a wallet special, a family certificate, your frame sale, and any other literature you can stuff in it to have it weigh the full ounce. This letter goes to all seniors who placed an order with you previously. It works well because graduation is fast approaching, which means they are looking for quantity wallets to put in their invitations.

Have a 16x20 sample letter sent out. This letter goes to every senior you think will make a good sample for you to display in your studio for the new class. The letter asks them to give you permission to use their photograph in your studio as display portraits. It gives them three options:

1. I do not give you permission to use my picture.

2. You have permission to use my picture.

3. Yes, and I also wish to purchase my portrait after you are finished using it for display.

If they choose the last option, ask to them to send in a check with their order and receive an additional $15.00 off the above price. You do

give them a choice as to which photograph will be displayed. When these envelopes come back yank out the checks first, then stack the letters in piles of those who gave you permission, those who did not, and those who paid. Find the negatives of those who paid and take them to your lab and order your 16x20. You would be remiss in your duties if you did not ask for a price break from the lab.

Send out prom letters to the schools whose proms you considering. Your goal is to get in to see the adviser.

Plan now to visit a principal of a school whose senior contract you will be seeking.

Engagement ad. In addition to lining up school work, this is a very good time to put in an ad aiming at all those women who got engagement rings for Christmas.

Wedding inquiries. January has always been a good month for wedding inquiries. Be prepared for them with good clean samples. If weddings is your interest, go after them by offering some sort of special if you wish.

Look for bridal shows or any place that will let you put up a display.

Valentine's Day special. Advertise your Valentine's Day special, a baby special, a frame special, etc. The whole idea for these months is to make the place look like a bargain basement store. Put stuff on the floor, on tables, place prices on everything. The important thing is to have something that will bring some traffic in. Think of your own promotion.

February

Have a frame sale. Send out direct mail about your annual frame sale. Most people cannot resist buying something at a store if it happens to have a price with an X through it and another price next to it. I use the two marked down approach.

Get rid of those frames you got stuck with. During the sale, your studio looks like a storm came through it with stuff strewn about everywhere. Frames are big business these days. I often wondered why I never felt the urge to add a frame place to my studio.

Run a frame sale ad in the newspaper. Put a sign in your window. "Up to 50% and even more off any frame."

Go after a prom. It is now time to get aggressive on going after a prom. Make that phone call or visit that adviser now. Get your Prom presentation ready to go and follow what we spoke about doing in our prom chapter.

The Valentine's Day special. Offer a Valentine's Day special or a baby special this month to your customer base using your customer base mailing list.

A restoration special. You can run a restoration special if you wish. It isn't going to be a big money maker for you, nevertheless, it can bring in some customers and make some new friends. You may offer an "As Is" special which says that says for only X dollars you will copy their treasured memento.

What you will get will be some older folks who really want to save certain pictures that are beginning to fade. You will be up front with them immediately by telling them that though the special does not

include any restoration work, if all they want is to keep this picture from fading any further, copying it "as is" will be fine.

Little leagues. Go after some little leagues. They are everywhere, boys, girls, All sports. And they are starting younger every year!

First Communions. Write some letters to churches for their first communions. Plan, plan, plan for your up upcoming season. Now work that plan.

Elementary or underclass photography. If I were you, I would look into this aspect of our business.

March

Easter special. Time to plan "The Easter special." This involves an Easter egg hunt when each child arrives at the studio. In addition to that, one of our employees voluntarily becomes the Easter Bunny. He or she is dressed in a rented Easter Bunny costume, and greets every child as they come in. If the mom insists, we will take a shot with the Easter Bunny in the picture.

You can work out a special deal involving the portraits with the Bunny if you can figure a way to have it work in your favor. The toughest part of this promotion is who will be the Easter Bunny.

The lil darlin' special is a cutie contest. To enter, the mom pays a fee which entitles them to a pre-determined package of portraits of their little darling. You can give one view to a photographer in another state who serves as the judge. Prizes are awarded to everyone with the top three getting awards. There are really no losers in this contest, as all the contestants get pictures from your studio, compete in the contest and you get some publicity. When you do this promotion advertise heavy and send out flyers galore. Also notify the local newspaper and let them know. Who knows, you may get some "free ink" out of the contest.

The pet special is another contest in which folks can bring in their animals, you can photograph them, and again have the photographs judged, and award ribbons, and prizes. Talk about publicity, free ink, and free air time, this event can really stir up a lot of interest.

The re-visited special. This is really a big production for us. Every customer who was photographed in the past year gets a letter asking them if they would like to appear in your 1997 Re-Visited display. Tell them that these portraits will be displayed in your gallery for the month of April. The letter goes on to ask them to give you permission to put their picture in your 1997 re-visited gallery. It also tells them that they may purchase this portrait for only X dollars when you are through with the display in June. The size of the picture is an 11x14 and is priced very low.

Most everyone who gets this letter realizes this is a very good price. It is an opportunity to purchase a portrait that they otherwise couldn't afford at the original purchase time. In other words, they know it's a good deal, even if it smacks of a promotion. The exciting part of this promotion is coming to the studio every morning and finding envelopes with checks in them shoved under your door. When the envelopes come in stack them in piles. Those who have paid, and those have not. Find all the paid negatives and take them to your lab and get candid

"There are really no losers in this contest..."

Giolas

NEED MORE WALLETS FOR FAMILY, FRIENDS AND GRADUATION ANNOUNCEMENTS?

Now is the time to order more wallet size portraits at special, very low prices...these are not copies! Each photograph is made from the original negative, rendering all of the definition, clarity and color brilliance that only an original negative can produce.

This special offer is available to any senior who has purchased and paid for an order! **You do not have to pay our normal re-order set up fee of $9.00 with this special offer!** This is a limited offer...so you must place your order now! If you order by mail, we will ship your wallet reorder to you **FREE!** Send your check, your name, address, phone number, school, and the pose you want and we will do the rest...add 5% sales tax of course. You can even reorder your typeset or hand-written imprint on these wallets at no charge (please call for details).

Call 769-7934 for more information.
Here are our special wallet prices: (from same pose)

24 wallets only $28	**32 wallets** only $33
40 wallets only **$40** *(our 40th Anniversary Special)*	**48 wallets** only $43
64 wallets only $49	**80 wallets** only $59
96 wallets only $69	**200 wallets** only $89

**Please add $9.00 set up per pose if ordering from more than 1 pose or from a new pose.*

ALSO AVAILABLE - LAST CHANCE PREVIEW SALE!!!

Any remaining previews can be purchased for only $4.00 each! You are welcome to come and browse through the previews you left behind - they can still make great gifts at only $4.00 each!

THE ABOVE SPECIALS EXPIRE APRIL 30th

Please send or bring in example of pose(s) you want to assure your order is processed correctly.
Payment is due in full at time of order - Sorry, no "Hold" orders)

special price on these 11x14's. When they come back, hang them up in one of your selling nooks every which way you can.

What about those in the stack of people who did not pay us but, gave us permission to use their portraits? Well, what about them? If someone comes in to view their picture in our gallery and can't find it, quickly look through your stack of those who did not pay, in which they will no doubt be. Tell them that you got such a large response, you are putting the pictures up in shifts in order to accommodate everyone who responded. "Yours will be up in about two weeks." When that person leaves, find that negative and get it to the lab pronto! Needless to say, when that person comes, back it will definitely be up there. My feeling on this promotion is that it is a good deal or everyone concerned; you get some needed cash flow, while the customer gets a very good break on an 11x14.

Have a spring cleaning sale. Think of other items you want to get rid of and try to get folks in one more time, by adding other items such as worn out folios, beat up frames, old albums, whatever. Just another way to keep your name in front of the public and possibly bring an some people.

The senior brochure. If you are planning a senior brochure (or any advertising brochure) this the time to get it ready. Gather all the possible prints you will be using on your brochure; work on your layout; have it ready to go to your printer. Once you have a nice layout, you can use the same layout for the next year, all you do is change the pictures and the year. Set a target date for April 1st and have that paste up or sketch with all the necessary information ready to go to a printer. Any local "quick-printer can do this for you.

April

This is get flyers and appointment letters ready month. Your main effort should be your senior appointment letters and flyers. The appointment letters and the flyers which go to your non contract schools are both the same on the outside.

The message however, changes on the inside depending on whether it's going to go to a contract senior or a non contract senior. If you have a school contract, the appointment letter is just what the word says. It is sent to all seniors who attend your contract schools and gives them an appointment time to be photographed.

Order just enough of those to cover the total number of students in your contract schools. The other flyers, which are also the same on the outside, will have information and coupons which can be used to purchase photographs from your studio.

The letter invites them to come to you for their senior portraits. The top half of the flyer is devoted to letting them know what you do and why they should come to you, while the lower portion of the letter consists of coupons. Send out three mailings, changing the main offer slightly each time. As the year progresses, offer a little bit less on the main attraction.

The ambassador program. This is a good time to set up your ambassador program for seniors (see senior chapter).

Make a senior picture display to be set up in a display case at the various schools. Target date for putting those up should be in the middle of May.

Get your people ready for the proms. Crews, supplies, folders, price lists, envelopes, bags, and whatever else you will need.

May

May is get ready for senior month. If you are not a senior studio get ready for your weddings.

Every thing you do this month, with the exception of the proms, is devoted to your senior season. This system involves pre stuffing all of your envelopes with order cards, preview mailer and post cards. Reason? When the first student comes in they will get a pre stuffed, pre numbered negative envelope in which is everything needed to write up that seniors sitting. You need to do everything you can during the slow time because once "zoo"time arrives you had better be ready. Are those appointment letters ready? Are those flyers ready?

Keep track of your weddings. Line up all the help you will need to cover those dates.

After your proms in mid May, if you are a school type studio, you do nothing but eat and sleep seniors. Are you ready to mail the appointment letters to the first contract school on about May 28th?

June

This month ushers in the beginning of "zoo" time at a senior studio. Get out your first mailing of non contract flyers or other direct mail. Hire all the help you will need.

Plan for your weddings. Make dry runs so you won't get lost on the day of the wedding.

Finally, at the Giolas Studio, we start photographing seniors.

July

This month the action continues as you photograph seniors. It is time to prepare the text for the next non contract mailing and get it ready for the printer.

Stay in tune with your weddings.

August

This month continues the pattern as you photograph more seniors, however now you will be at peak performance in the work room also. Mail the second mailing to the non contract seniors.

Homecoming dances. Go get some using the same technique as you did on proms.

Weddings. Book them.

September

Still photographing seniors and also delivering finished orders.
Get ready for any homecoming dances you may have picked up.
Start thinking about the Christmas advertisement.
Weddings.

"Make dry runs so you won't get lost on the day of the wedding."

YEAR AT A GLANCE

January

- Look over price lists
- Cash flow sale
- Senior wallet special
- Send out 16x20 letter
- Send out prom letters
- Engagement Ad
- Wedding inquiries
- Bridal shows
- Valentine's Day special ad
- Weekly staff meetings

February

- Have a frame sale/run ad
- Go after a prom
- Valentine's Day special
- Restoration special
- Little leagues
- First Communions
- Elementary photography
- Prepare Easter special ad
- Weekly staff meetings

March

- Easter Special
- Lil Darlin' contest
- Pet special
- Re-Visited special
- Spring cleaning sale
- Prepare senior brochure
- Weekly staff meetings

April

- Prepare senior flyers
- Senior appointment letters
- Ambassador Program
- Senior picture display
- Get ready for proms
- Weekly staff meetings

May

- Get ready for seniors
- Stuff senior sitting packets
- Get ready for weddings
- Proms
- Mail appointment letters
- Weekly staff meetings

June

- First non contract mailing to seniors
- Direct mail
- Weddings
- Hire extra help if needed
- Weekly staff meetings

July

- Photographing seniors
- Prepare 2nd non contract mailing (seniors)
- Weddings
- Weekly staff meetings

August

- Photographing seniors
- Homecoming dances
- Book weddings
- Send out 2nd non contract mailing (seniors)
- Weekly staff meetings

September

- Photographing Seniors
- Delivering finished senior orders
- Plan Christmas ad
- Weddings
- Weekly staff meetings

October

- Photographing seniors
- Christmas sign in window
- Weddings
- Weekly staff meetings

November

- Start Christmas ads
- Send out 3rd non contract mailing (seniors)
- Direct mail
- Christmas gift certificates
- Plan Christmas dances
- Weekly staff meetings

December

- Christmas ads/specials
- Christmas dances/parties
- Decorate studio
- Weekly staff meetings

October

Still servicing seniors.
Put your Christmas sign in the window.
Still doing weddings.

November

Start your Christmas advertising this month. For a few years, I went into the "insurance" business. That's right! I sold "Memory insurance." Isn't that what we do? Think about it. Now is the time to offer a Christmas special. Great time to advertise that you help keep families together: "Here today, grown tomorrow." Kodak has a bunch of good lines.

Run your Christmas ad. (Memory insurance ad, specials etc. run a gift certificate ad.) Start scheduling family portraits.

Send the third non contract mailing. Be ready to photograph your Christmas orders and send out some direct mail, which can include Christmas special, gift certificate flyer.

December

Plan for any Christmas dances you may have.

*Run a Christmas gift certificate ad...*A family ad (they are all home for Christmas).

Decorate the studio. This should be a team affair as it helps all of us get in the Christmas spirit.

"The key word here is organization."

Conclusion

When you started reading this book, I hope you determined Giolas attempted to make everything he did as easy as possible and still put out a saleable product. The key word here is organization. People who are organized get more done than people who are not. Goals should be set. Some will be achieved, others won't. Plans should be made. Setting goals is important and making plans is a necessity.

It is your attitude not your aptitude that will bring you success. A good way to succeed over risk and change is to never stop learning. It is okay to take some risks.

Finally, when you are just starting out, and even throughout your career, ask yourself, where am I now, and where do I want to go? Then visualize, picturize, and plan. Have a vision first, picture yourself there, then devise a plan that will get you there.

Glossary

220 Film: Film that offers 24 exposures, or 20 exposures or 30 exposures depending on which camera format you use.

120 Film: Film that offers 10, 12, or 15 exposures depending on which camera format you use.

Background Light: This light is used to give the subject some separation from the background.

Bounce Flash: Flash that is bounced off of the ceiling, a wall, an umbrella or a reflector, and then goes to the subject.

Broad Lighting: The highlight side of the face is closest to the camera.

Bust Pose: A head and shoulders pose.

Butterfly Lighting: Light coming from directly above the camera causing a shadow just below the nose.

Cookies: These are metal cutouts of patterns used in the spotlight to create patterns on the background.

Direct Flash: A light source that goes from flash head direct to the subject.

Fill Light: This light subtly fills in the shadows created by the Main (or modeling) light.

Full Length: A pose that shows the entire body.

Gel: A heat resistant colored piece of plastic used to alter the color of a light.

Grip: This is the handle, if you will, with which you hold your camera for off tripod shooting.

Hair Light: The light used to light the hair.

High Key: A lighting that puts four times the light on a white seamless background than it puts on the subject is called Hi-Key lighting.

Interchangeable Film Back: A film back holder that allows you to change backs in mid roll, without exposing the film.

Kicker Light: Some times used as an additional light source to enhance the main light.

Lens Diffusion: A softening filter that is placed over the lens for a more pleasing blend of shadows and highlights.

Light Diffusion: Material placed in front of the light reflector giving you softer shadows.

Light Head: The flash that is powered by the power pack.

Light Ratio: The total amount of light falling upon the highlight side, relative to the shadow side. The ratio is expressed numerically.

Low Key: A lighting which puts no lighting, (or hardly any) on the old masters type dark background and produces slightly heavier shadows on the subject.

Main Light: This the light that creates the modeling of the portrait.

Medium Format Camera: A camera that exposes a film size between 2¼ and 3¼ inches.

Modeling: This refers to a light (as in main light) that creates the "modeling" of the face.

Muslin: Cloth in 9 and 12 feet widths and 15 foot lengths used as a backdrop. Comes in various colors and can be used on location as well as the studio.

Parabolic Lights: A light with a reflector which goes directly to the subject. For example, a 16 inch reflector used as a main light.

Photo Cell: A light sensitive device that uses the light from another flash to trigger any flash it is plugged into.

Power Pack: This unit powers the flash heads that are plugged into it.

Profile Lighting: Lighting coming in from the side into which the subject is looking and lights the forehead nose and chin. (Subject must be in a profile pose.)

Punch Light: A smaller light source used to add some "punch," or "snap" to a particular area of the portrait.

Quantum Batteries: A portable High capacity re-chargeable battery used on any location photography

Radio Device: Works with a transmitter on the main flash and a receiver on the 2nd flash as it uses a radio frequency to fire the flash units. (The main flash unit triggers the 2nd flash.)

Rembrandt Lighting: Lighting that comes from a 45 degree angle and places a triangle of light on the shadow side of the face (the side furthest from camera).

Short Lighting: The shadow side of the face is closest to the camera.

Snoot: An attachment over a light to bring that light down to a smaller area of coverage (as in hair or background light).

Soft Box: A light in a box that bounces light through baffled material and sends it out of the translucent front panel. Produces a soft forgiving wrap around lighting effect.

Split Lighting: Light coming in from the side highlighting one side of the face only. The shadow side is in compete shadow.

Spotlight: This light, which produces a very intense sharp shadow, is used with "cookies" to create special effects on the background. Can be used as a main light also.

Telephoto Lens: Allows you to come in closer on portraits without getting distortion. For example, head and shoulder shots. In portrait photography this can also be called the 'portrait lens,' and is usually 150 mm.

Three-Quarter Length Pose: A pose that includes body down to the approximately the knees.

Top Light: This is lighting is bounced off of the ceiling directly above the subject in the full length area.

Tripod: A sturdy holder for all of your portrait photography.

Umbrella: A light bounced into a large umbrella. Creates a non direction light with a wide coverage.

Wide Angle Lens: A lens that gives a wider view of any subject without sacrificing distance from subject (as in large groups).

Zone Focus: Pre-Focusing on an area. Then waiting until the subject gets to the designated spot and taking the picture.

Index

Other Books from Amherst Media, Inc.

Basic 35mm Photo Guide
Craig Alesse

Great for beginning photographers! Designed to teach 35mm basics step-by-step — completely illustrated. Features the latest cameras. Includes: 35mm automatic and semi-automatic cameras, camera handling, *f*-stops, shutter speeds, and more! $12.95 list, 9x8, 112p, 178 photos, order no. 1051.

Don't Take My Picture
Craig Alesse

This is the second edition of the fun-to-read guide to taking fantastic photos of family and friends. Best selling author, Craig Alesse, shows you in clear, simple language how to shoot pictures, work with light, and capture the moment. Make everyone in your pictures look their best! $9.95 list, 6x9, 104p, 100+ photos, order no. 1099.

Build Your Own Home Darkroom
Lista Duren & Will McDonald

This classic book shows how to build a high quality, inexpensive darkroom in your basement, spare room, or almost anywhere. Information on: darkroom design, woodworking, tools, and more! $17.95 list, 8½x11, 160p, order no. 1092.

Into Your Darkroom Step-by-Step
Dennis P. Curtin

The ideal beginning darkroom guide. Easy to follow and fully illustrated each step of the way. Information on: equipment you'll need, set-up, making proof sheets and much more! $17.95 list, 8½x11, 90p, hundreds of photos, order no. 1093.

Camera Maintenance & Repair
Thomas Tomosy

A step-by-step, fully illustrated guide by a master camera repair technician. Sections include: testing camera functions, general maintenance, basic tools needed, basic repairs for accessories, camera electronics, plus "quick tips" for maintenance and more! $24.95 list, 8½x11, 176p, order no. 1158.

Camera Maintenance & Repair Book 2
Thomas Tomosy

Advanced troubleshooting and repair building on the basics covered in the first book. Includes; mechanical and electronic SLRs, zoom lenses, medium format, troubleshooting, repairing plastic and metal parts, and more. $29.95 list, 8½x11, 176p, 150+ photos, charts, tables, appendices, index, glossary, order no. 1558.

Restoring Classic & Collectible Cameras
Thomas Tomosy

A must for camera buffs and collectors! Clear, step-by-step instructions show how to restore a classic or vintage camera. Work on leather, brass and wood to restore your valuable collectibles. $34.95 list, 8½x11, 128p, b&w photos and illustrations, glossary, index, order no. 1613.

Big Bucks Selling Your Photography
Cliff Hollenbeck

A complete photo business package for all photographers. Includes secrets to making big bucks, starting up, getting paid the right price, and creating successful portfolios! Features setting financial, marketing and creative goals. This book will help to organize business planning, bookkeeping, and taxes. $15.95 list, 6x9, 336p, order no. 1177.

The Wildlife Photographer's Field Manual

Joe McDonald

The complete reference for every wildlife photographer. A practical, comprehensive, easy-to-read guide with useful information, including: the right equipment and accessories, field shooting, lighting, focusing techniques, and more! Features special sections on insects, reptiles, birds, mammals and more! $14.95 list, 6x9, 200p, order no. 1005.

Infrared Photography Handbook

Laurie White

Covers black and white infrared photography: focus, lenses, film loading, film speed rating, heat sensitivity, batch testing, paper stocks, and filters. Black & white photos illustrate how IR film reacts in portrait, landscape, and architectural photography. $24.95 list, 8½x11, 104p, 50 b&w photos, charts & diagrams, order no. 1419.

The Art of Infrared Photography / 4ᵗʰ Edition

Joe Paduano

A practical, comprehensive guide to the art of infrared photography. Tells what to expect and how to control results. Includes: anticipating effects, color infrared, digital infrared, using filters, focusing, developing, printing, handcoloring, toning, and more! $29.95 list, 8½x11, 112p, order no. 1052.

Infrared Nude Photography

Joseph Paduano

A stunning collection of images with informative how-to text. Over 50 infrared photos presented as a portfolio of classic nude work. Shot on location in natural settings, including the Grand Canyon, Bryce Canyon and the New Jersey Shore. $29.95 list, 8½x11, 96p, over 50 photos, order no. 1080.

Black & White Nude Photography

Stan Trampe

This book teaches the essentials for beginning fine art nude photography. Includes info on finding your first models, selecting equipment, scenarios of a typical shoot, and more! Includes 60 photos taken with b&w and infrared films. $24.95 list, 8½x11, 112p, index, order no. 1592.

Swimsuit Model Photography

Cliff Hollenbeck

A complete guide to swimsuit model photography. Includes: finding and working with models, selecting equipment, posing, props, backgrounds, and much more! By the author of *Big Bucks Selling Your Photography* and *Great Travel Photography*. $29.95 list, 8½x11, 112p, over 100 b&w and color photos, index, order no. 1605.

Glamour Nude Photography

Robert and Sheila Hurth

Create stunning nude images! Robert and Sheila Hurth guide you through selecting a subject, choosing locations, lighting, and shooting techniques. Includes information on posing, equipment, makeup and hair styles, and much more! $24.95 list, 8½x11, 144p, over 100 b&w and color photos, index, order no. 1499.

Wedding Photographer's Handbook

Robert and Sheila Hurth

The complete step-by-step guide to succeeding in the exciting and profitable world of wedding photography. Packed with shooting tips, equipment lists, must-get photo lists, business strategies, and much more! $24.95 list, 8½x11, 176p, index, b&w and color photos, diagrams, order no. 1485.

Lighting for People Photography

Stephen Crain

The complete guide to lighting. Includes: set-ups, equipment information, how to control strobe and natural lighting, and much more! Features diagrams, illustrations, and exercises for practicing the lighting techniques discussed in each chapter. $29.95 list, 8½x11, 112p, b&w and color photos, glossary, index, order no. 1296.

Handcoloring Photographs Step-by-Step

Sandra Laird & Carey Chambers

Learn to handcolor photographs step-by-step with the new standard handcoloring reference. Covers a variety of coloring media. Includes colorful photographic examples. $29.95 list, 8½x11, 112p, 100+ color and b&w photos, order no. 1543.